MICHAEL FREEMAN'S PHOTO SCHOOL
EXPOSURE

EDITOR-IN-CHIEF **MICHAEL FREEMAN**
WITH **JEFF WIGNALL**

ILEX

First published in the UK in 2012 by

I L E X

210 High Street
Lewes
East Sussex BN7 2NS
www.ilex-press.com

Publisher: Alastair Campbell
Associate Publisher: Adam Juniper
Creative Director: James Hollywell
Managing Editor: Natalia Price-Cabrera
Specialist Editor: Frank Gallaugher
Editor: Tara Gallagher
Senior Designer: Kate Haynes
Designer: Lisa McCormick
Colour Origination: Ivy Press Reprographics

British Library Cataloguing-in-Publication Data
A catalogue record for this book is available
from the British Library

ISBN: 978-1-908150-27-1

Printed and bound in China

10 9 8 7 6 5 4 3 2 1

Photo on page 4 © Mikhail Basov
Photo on page 14 © Viktoria Makarova
Photo on page 94 © Nazmoo – Fotolia
All other photography © Michael Freeman
unless otherwise noted.

Contents

FOREWORD

About This Series

Photography is what I do and have done for most of my life, and like any professional, I work at it, trying to improve my skills and my ideas. I actually enjoy sharing all of this, because I love photography and want as many people as possible to do it—but do it well. This includes learning why good photographs work and where they fit in the history of the craft.

This series of books is inspired by the structure of a college course, and of the benefits of a collective learning environment. Here, we're setting out to teach the fundamentals of photography in a foundational course, before moving on to teach specialist areas—much as a student would study a set first-year course before moving on to studying elective subjects of their own choosing.

The goal of these books is not only to instruct and educate, but also to motivate and inspire. Toward that end, many of the topics will be punctuated by a challenge to get out and shoot under a specific scenario, demonstrating and practicing the skills that were covered in the preceding sections. Further, we feature the work of several real-life photography students as they respond to these challenges themselves. As they discuss and I review their work, we hope to make the material all the more approachable and achievable.

For you, the reader, this series provides, I hope, a thorough education in photography, not just allowing you to shoot better pictures, but also to gain the same in-depth knowledge that degree students and professionals do, and all achieved through exercises that are at the same time fun and educational. That is why we've also built a website for this series, to which I encourage you to post your responses to the shooting challenges for feedback from your peers. You'll find the website at **www.mfphotoschool.com**

Student Profiles

Lukasz Kazimierz Palka

Lukasz is a Polish-born urban photographer based in Tokyo, Japan. He is known for his street photography and exploration of the metropolitan landscape and its natural environs. Lukasz established himself in Tokyo in 2009, and began shooting out of a curiosity about the city and its people. He has been documenting Tokyo for over two years, while also making excursions to China, Australia, and other nations in the eastern hemisphere.

Lukasz's photographic style has yet to crystallize, but can be described as "cinematic." He is inspired by films such as *Blade Runner* and sci-fi manga such as *Ghost in the Shell*. Through his work, he aims to show the world a glimpse of what he sees, casting a light on the moments that daily emerge and fade in our cities. His inspiration comes from one of the largest human conglomerations on earth: Tokyo.

Currently, Lukasz is a hustling freelancer, primarily a Photographer, Graphic Designer, and Educator. More of his work can viewed at **www.lkazphoto.com**

Richard Gottardo

Richard is a creative modern wedding and fine art photographer based out of Toronto, Canada. Initially he began his career in the pharmaceutical industry working in a polio lab. As photography began to grow from more than just a passion and a hobby into something he could make a career out of, he left pharmaceuticals behind in order to begin a photography business.

Currently he is looking into opening a studio in Toronto. He got his first real taste of photography came while taking a miksang photography course in university. *Miksang* is a Tibetan word that means "seeing with a good eye" and being able to find beauty in everyday things. He has tried to keep to this philosophy and photography for him has become way to escape the mundane and explore the beauty present all around us. His work can be found at **www.richardgottardo.com**

Nick Depree

Born in Christchurch, New Zealand, Nick traveled a lot at a young age before settling into University studies in Auckland where he completed a Bachelors degree and eventually a Doctorate in Chemical and Materials Engineering. Nick got into photography around 2006, quickly becoming comfortable with the technical aspects, and has since been more interested in developing his artistic and aesthetic side, while also enjoying trying various types of modern and vintage, digital and analog cameras.

Living in New Zealand provides great opportunities for landscape photography, which was Nick's early interest, but he found his productivity and quality of output greatly increased in the past two years with the opportunity for extensive travel through his research work. Exploring new cities and countries has become his passion, where he finds his best shots by walking the streets for long periods, being observant of his surroundings and patient for the right light or scene to appear. He also very much enjoys learning about the history and culture of new places, and photographing the details, foods, and historical locations he finds.

You can find his work at
www.ndepree.com

Nathan Biehl

Nathan was born in a small town nestled in the north woods of Wisconsin, USA. After bouncing around the Midwest for most of his life, he now claims Iowa City, Iowa as his home. His current day job is as a graphic designer, and while his 9 to 5 is devoted to design, his free time is consumed by photography.

Nathan attended the University of Northern Iowa where he received a BFA in Printmaking. Originally, his photography served as a reference point for his prints, but soon after graduating it evolved into be his primary creative focus.

While his educational background was in the arts, his only formal training in photography was an introductory class covering the basics of black-and-white photography. Nathan welcomes every chance to expand his photographic knowledge by pouring over any book, blog, or gallery he can find.

To view more of his work, visit
www.biehl.me

Introduction

With all the measurement and processing advantages of digital photography, exposure has been made easy to take for granted. The automatic exposure functions on today's cameras are impressive pieces of technology, and indeed they are quite capable of producing excellent images all on their own (hence the Auto setting on virtually every single modern camera). There is something to be said for this, as it makes photography considerably more inviting and approachable, and is in no small part responsible for the democratization of photography that we've been enjoying for several decades (aided by autofocus, always-with-you cell-phone cameras, advanced post-production tools, and the ease of sharing and displaying digital images online).

Yet, there is a significant drawback to this trend toward automation. More and more, exposure is rigidly understood as something that is either right or wrong—a problem to be solved. There is an element of truth in this, insofar as there is, in the end, just one dosage of light, manipulated by shutter speed, aperture, and ISO (or film speed), just as it has been for over a century. For all that we wax philosophical about how to interpret exposure, the final decision is a straightforward combination of just three simple factors. The problem is that viewing exposure in such a clinical way robs you, as a creative artist, of a significant and, frankly, enjoyable component of your art. There is another open-ended, highly subjective side to exposure. Two

people can view the same scene and choose to represent it in entirely different ways—and we should be thankful for this, or else there would be little room left for innovation and expression. How you choose to capture a scene depends on your receptiveness to the subtle interplays of light and shadow, what you consider significant versus peripheral, the mood you want to impart to the viewer, and so on. Over time, these exposure decisions will form your personal aesthetic style. Some like it bright, some like it dark. Some need everything tack-sharp, others don't mind soft edges and a bit of blur. Photography is big enough to accommodate all these approaches, and exposure is the means by which you can achieve them.

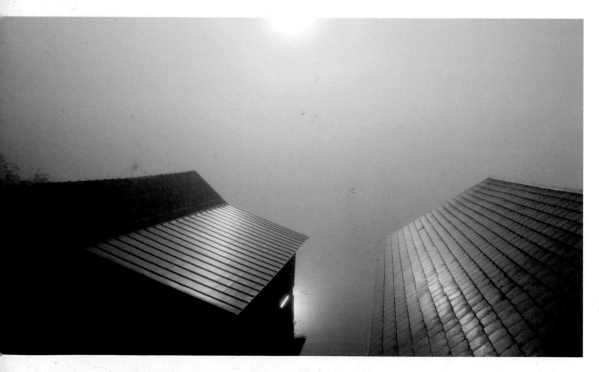

← **How and when to shoot**
Even the timing of your shot is an exposure decision—do you wait for the sun to reemerge from behind a cloud, or (in this case) for the fog to pass? Or do you embrace the current conditions? Such questions require confidence equally in both your aesthetic sensibilities and technical prowess.

And that will be the purpose of this book: to give you a thorough understanding of the exposure tools available, so that when the moment calls for it, you can not only determine the optimal settings for the best exposure, but also what that "best" exposure is, and what other options and interpretations potentially exist. As part of this, we will also be emphasizing the moment of capture over any post-production workflows, with the goal being to capture optimal data in-camera. For one, doing so will give you the most leeway during post production if you do go on to edit your files, but more importantly, this approach will reinforce the significance of your exposure decisions each step of the way, so you can work knowledgeably and effectively.

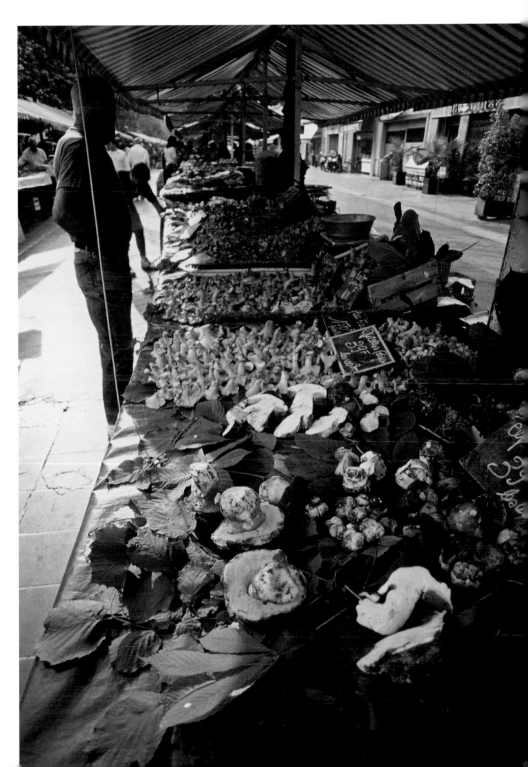

→ A coherent decision
Exposure is an inseparable part of every photographic decision. For instance, as this shot of a market is being composed, design choices as to where to line up various elements within the frame invariably impact the placement of shadows and highlights, which must be considered simultaneously and on-the-fly.

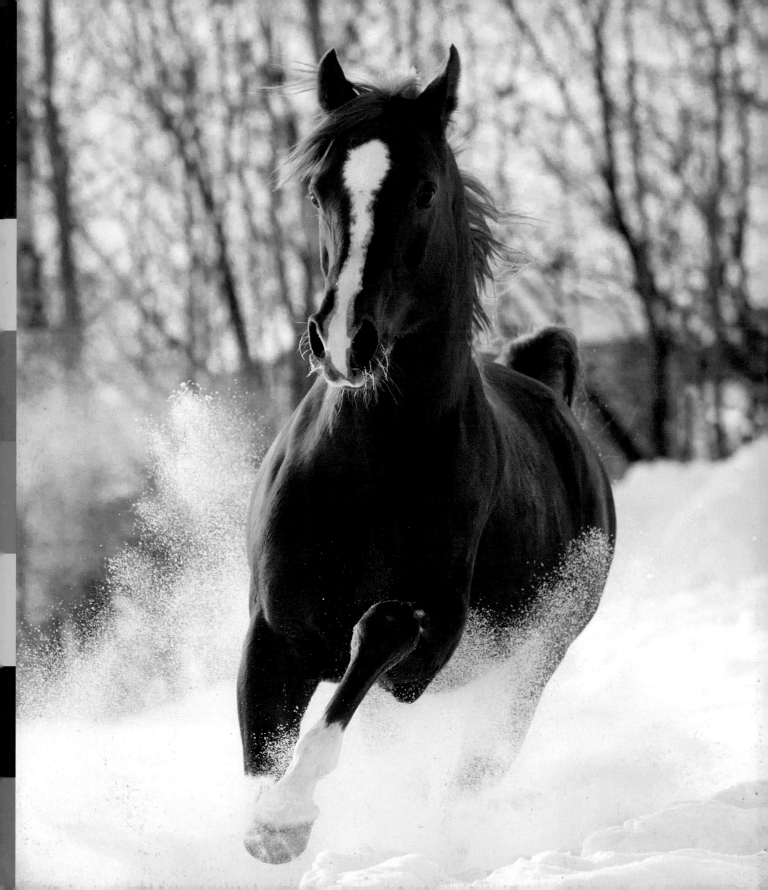

Fundamentals

Creating a good exposure is the essence of any successful photograph. Even the best creative ideas and the most dramatic of situations will fall flat if careful attention is not given to how the tonalities of a particular scene are recorded. And conversely, even rather mundane subjects can be transformed into exciting photographs when creatively seen and recorded using well-considered manipulation of exposure controls.

It's easy to think that with today's sophisticated metering and exposure systems and the ability to record images in the Raw format (where changes can be made to exposure after the fact) that good exposure is "automatic" or that the camera (and software) will do the work for you. But good exposure is more than merely recording the tonalities within a given scene correctly; it's also largely a matter of personal perception and the result of many choices—both artistic and technical. No technology can replace the inspired work of an active imagination, though it can certainly help you to capture that vision.

Learning to create not only competent but visually arresting exposures then is a matter of two things: learning to see the potential for dramatic exposures in familiar situations, and then knowing how to achieve them with the right combination of shutter speed, aperture, and ISO setting. The trick, of course, is to learn to master both of these skills so that you can apply them instinctively, consistently, and effortlessly.

A Record of Tonalities

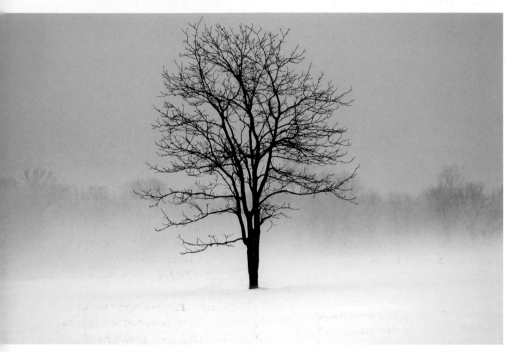

© Stephen VanHorn

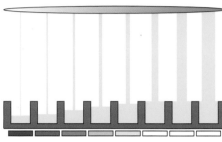

↑ Filling the photosites

Once the camera's shutter opens, the photosites (pixels) on the sensor's surface begin to fill with light. The more light, the fuller the well and the lighter the tone will be. But when completely full, the result is featureless white.

← Simple settings, complex solutions

Understanding how basic camera settings control the amount and duration of light that reaches your camera's sensor is at the root of all exposures. Master this knowledge and no subject is beyond your control.

At its most basic, exposure is about one thing: getting the ideal amount of light to the camera's digital sensor so that the scene is captured as closely as possible to the way that it looked to you at the time. Record too much light and the image is overexposed and the image is too bright—shadows are bland and highlights are completely without detail. Capture too little light and your image is underexposed—shadows are cast into dark blobs void of detail, and highlights and middle tones are muddled. In most (not all) cases, the ideal exposure lies somewhere between those two extremes.

In purely technical terms, your camera provides a nearly perfect vehicle for capturing a good exposure. Given the proper instructions (from you), it will do just that. In fact, it was designed largely with that singular goal in mind: to record the tonalities of a scene so that they will appear as recognizably as possible in the final photograph.

Technically then, your goal (and the camera's function) is to record the values in a scene in a way that looks similar to what your eyes saw. In a winter landscape, for instance, you want the snow to look white, the dark tree trunks to be nearly black and most of the rest of the scene to fall between the two. Using just a light meter and few exposure controls, capturing such an exposure can be reduced to a very predictable process. A lot of clever engineering has gone into making the process quite painless, giving you time to concentrate on the creative side.

As you start out in photography, knowing how to carefully combine the settings of those exposure controls is an essential skill to master in order to create a good technical exposure. And as with any new skill, learning these fundamentals is at the core of creative growth. Great jazz musicians can't fly off into an inspired improvisation, can't twist and explore and return to a melody until they have mastered the basic skills of playing that melody first. Photography is very similar: You must know how a camera captures and records light and before you can alter that response.

Human Versus Digital Dynamic Range

Unfortunately (or perhaps fortunately, depending on your point of view), the way that your camera sees the world and the way that it appears to your eyes and brain are two radically different things. For one, your eyes have an astounding and extremely rapid ability to see an extraordinary contrast range. It's nothing for your eyes to see detail in the darkest shadow of a rock at midday and then, in a flicker, find detail in the white petals of a sunlit flower. Your eyes and brain together are constantly and relentlessly adjusting to the brightness range or "dynamic range" of your surroundings. Focus on a shadow and your pupils open to accept more light. Glance into a sunlight patch, your

pupils close down instantly to control the burst of light. Given time to adjust to the changing conditions, your eyes can see across a dynamic range that is equal to more than 24 "stops" in camera terms.

Your camera, on the other hand, is limited to capturing the finite dynamic range of its sensor—with contemporary sensors a range of 10–14 stops of light, depending on the particular camera model. If you exceed that range at either end by trying to include too broad a range of darks and lights, something has to give: You will lose one end of the dynamic range or the other. There are methods, such as high-dynamic-range imaging, for extending that range and we'll discuss those later in this book.

The challenge of a good exposure is to work within the fixed limitations of a camera's technology while at the same time exploiting the maximum emotional content from your subjects. And that is essentially what this entire book is about.

Controlling Exposure

Given the creative range that exposure can produce in a photograph, it's interesting that exposure is entirely a product of just three camera controls: ISO setting, lens aperture, and shutter speed. Every exposure, every creative effect, and every manipulation or exaggeration of the light is created by the careful and clever combination of those three settings.

ISO numbers are a relatively recent invention, but throughout the history of photography, the sensitivity of emulsions has been a factor, and these three controls haven't changed fundamentally since the earliest days. We can calculate exposure times in thousandths of seconds or use standardized apertures and ISOs, but the basic concepts remain the same.

←↓↘ Tough decisions
While your eye has no trouble seeing details in both the shadow areas at the edge of this frame, and the bright highlights in the center, your camera often needs to choose either one or the other, which can result in an underexposure (below, left), or an overexposure (below, right).

Right Versus Wrong Exposure

One of the concepts that it's important to eliminate, or at least try to suppress a bit as you begin to experiment with exposure, is that for every single possible photo, there is necessarily such a thing as a right or wrong exposure. While you certainly want to understand how to capture the tonalities in a scene so that you aren't sacrificing essential detail in the highlights or shadows, for instance, you don't need to adhere to anyone else's definition of what a correct exposure should look like. Exposure is no more about right or wrong than is the amount of milk you put in tea, or the temperature of your beer.

While most of us see a colorful sunset as a cheerful and brilliant sky event, for example, there is nothing wrong with

grossly underexposing that scene to artificially over-saturate the colors. Nor is there anything wrong with providing too much exposure and creating a more lyrical high key interpretation (see page 124 for more on high-key exposures). Most great strides in art, in fact, have been achieved by those brave souls that have pierced through the realm of conventional barriers and expanded the territory of what is correct. Picasso, Van Gogh, Monet—all took the norms of art and tossed them in the trash. (Though you can be certain that all knew the standard techniques well before shattering them.)

↓ **Underexposed for drama**
One man's underexposure is another's idyllic sunset. As you become comfortable with the nuances of exposure, its technically accuracy will take on a more subjective outlook.

Were the entire world and all its scenery colored a consistent middle-toned gray, there would be no need for this book, as your camera would never struggle to determine its exposure. Quite fortunately, the world is a bit more varied than that. Subjects present themselves in every color of the rainbow, illuminated by a wide variety of lighting conditions (which themselves have their own subtle colors—as we'll discuss on page 84), struck at angles that reveal contours and textures that can be highlighted or hidden at your discretion.

↓ **Overexposed for vibrancy**
This shot required a creative override of the camera's metering system, which typically fights against letting massive areas of the frame blow out to pure white.

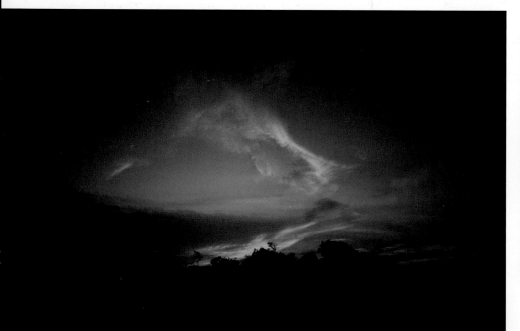

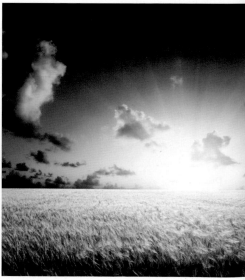

© Iakov Kalinin

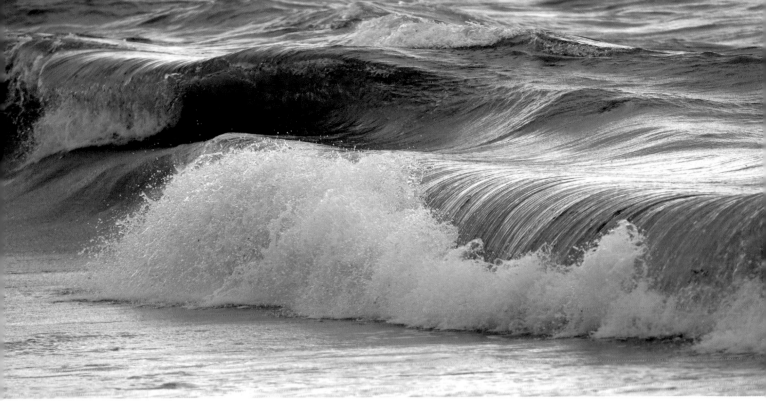

© Emin Ozkan

That discretion and creative choice over how you choose to capture and represent any given scene is your most powerful tool. Your camera, even with its highly advanced, built-in metering system, is only a computer, with no sense for the creative potential before it. It is entirely up to you to take control and learn when to override your camera's decisions and assert your own vision for your photography.

Some of that creative vision will be a matter of deviating from your camera's suggested exposure measurements—recognizing that, in fact, you prefer this scene with heavy, blocked-up shadows and a resulting sense of brooding and dread, or another scene with so much pure bright white that you can just barely make out your subject emerging from an ethereal cloud. Other times, you will depend entirely on a precise exposure reading from your camera, but you will still need to carefully ensure that it is reading of the specific

↑ Not always shooting for a catalog
If the goal was to accurately represent the shape of an apple, this photo would be a failure. But the apple itself isn't what was important; rather, it was the interplay of light and shadow.

© Elenathewise

↑ Countless possibilities
There are countless ways to capture this wave—a high shutter speed to freeze each drop, or a slower one for a more painterly effect; cold white balance to keep the blues of the water intact, or warm to infuse the image with a golden hue.

area of the scene off of which you want to base your exposure. There is never a place in this photographic journey in which you should not be asserting yourself as the ultimate decider of proper, ideal, or "right" exposure.

With that framework in mind, when the terms "good" or "bad" exposure are used in this book, we are only talking in the strictest technical sense. In terms of aesthetics, you are the only arbiter of right or wrong, good or bad, creative or imaginative.

Underexposure & Overexposure

Underexposure

Images that are underexposed, either intentionally or by poor exposure choices, are those that appear darker than they did to the eye (or than the viewer's experience suggests) because they haven't received enough light. Often, scenes can be underexposed by design to give them drama or mood. In the Venezuelan Andes scene below, for example, intentional underexposure was used to contrast the brilliance of the white buildings against the overshadowing of the dark mountain shapes. A slight amount of underexposure can be a good tool for saturating colors and bringing highlights under control—a good technique when shooting landscapes where you want to stress the intense colors of the sky without letting them overflow into pure white. Too much underexposure, however, tends to hide details and textures in shadow areas, and bunches up darker tonalities rather than revealing subtle nuances in the dark areas of a scene.

Generally speaking, even when you are underexposing for dramatic effect, it's rare that you want to lose all details in darker areas of a scene, partly because such an exposure will also drag highlights down—though again, this is a purely subjective decision. There is nothing wrong, for instance, with exposing for the delicate light tones of a clump of white tulips blossoms so that the highlights become closer to middle tones and the shadows become a field of black around them. In such a scene the tulips themselves would lose their bright delicacy and fall into a more neutral palette, but this can add to the unexpectedly dark mood of the scene. Often just the surprise factor of such extreme underexposure is enough to draw attention to an image.

↓ **Through a glass, darkly**
Intentional underexposure is a wickedly powerful tool for exaggerating or even fabricating the mood of a place. What the meter thinks is too little may be just enough.

↓ **The riches of saturation**
Correct exposure is fine for family snapshots, but art comes from having the courage to depart from reality. Just a few stops of underexposure turn tulips from ordinary to elegant.

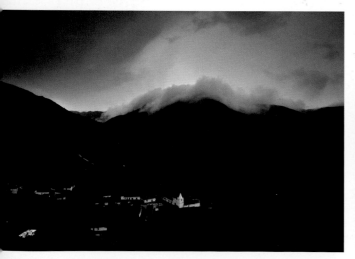

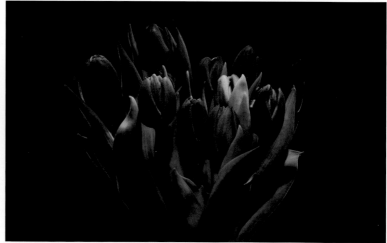

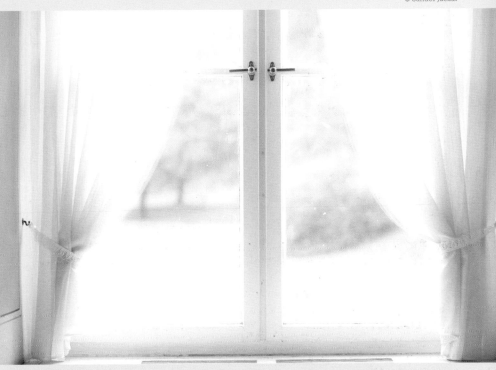

© Sandor Jackal

Overexposure

Overexposure happens when a scene gets more light than is required for a "normal" exposure, and tones are recorded as lighter than they appear to the eye or to expectations. The danger of overexposing scenes is that, even when slight, detail may be completely lost in the lightest tones. There is a fine line between capturing the delicacy of a white swan feather, for example, and losing detail completely. Digital sensors are more prone to overexposure errors than is film and for that reason you'll often hear the advice that you should "expose for the highlights" when shooting digitally. By exposing so that highlight areas retain fine detail you avoid having "blank" areas in the lighter tones where there is simply no discernible detail or surface texture.

Creative use of overexposure with certain types of subjects can produce interesting visual effects and often establishes a light, cheerful interpretation, particularly with light-toned and pastel-colored subjects. If you're photographing a field of tall yellow grasses in brilliant sunshine, for example, a small amount of intentional extra exposure will exaggerate the dreamy, romantic quality of the scene. The danger of too much exposure, however, is that you'll lose so much detail in brighter-toned areas that the image will cross into the realm of abstraction or impressionism. That's not a problem if it's your intention, but often such scenes just look like they were made with sloppy exposure technique—it's a fine creative line.

In general, the rule in digital exposure is to expose for the highlights and correct for the shadows in editing.

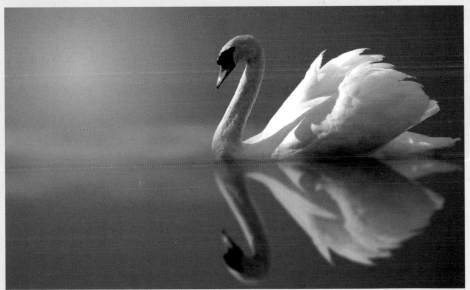

© Joss

↑↑ **Bright window light**
Too much light? Depends on the mood you're trying to establish. A bit of overexposure adds lightness to the atmosphere of a photo, as well as the tonalities.

↑ **Clipped wings**
"Clipping" is a term used to describe highlights that have received too much exposure and lost all detail as a result. It's unavoidable in some situations, but should always be carefully monitored.

Creative Use of Over- or Underexposure

↓ Overexposure as a choice
The dynamic range of the frame required a creative exposure decision one way or the other, and having the sledder emerging from a bloom of pure white on the right seemed more fitting.

"Correct" exposure is the result of a combination of exposure settings that renders the world the way that most people perceive it: Light-toned subjects are bright but detailed, shadows are dim but accessible, and in terms of overall tonality, most things look pretty much as we perceive them day to day. But as you now know, with an intentional shift toward underexposure or overexposure, you can radically transform not only the look of a scene, but its emotional climate, as well.

By making a wholesale shift toward lighter tones, for example, you can transform a morning meadow into a lifting, high-key melody; by subtracting exposure from already dim scene of an industrial block you drag it down into a gloomy low-key dirge. And that is what your challenge is all about: using the extremes of exposure to value mood and expression above reality.

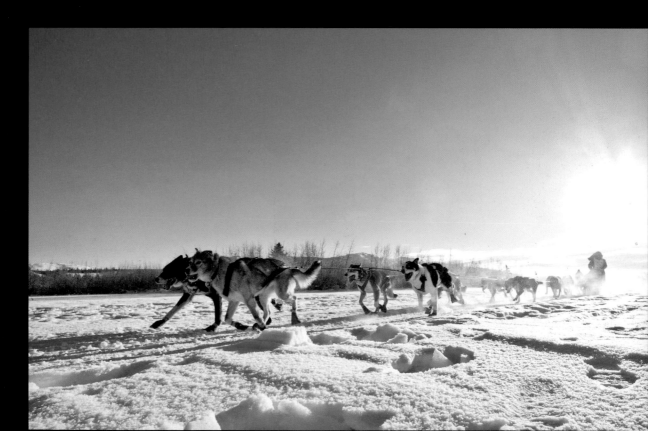

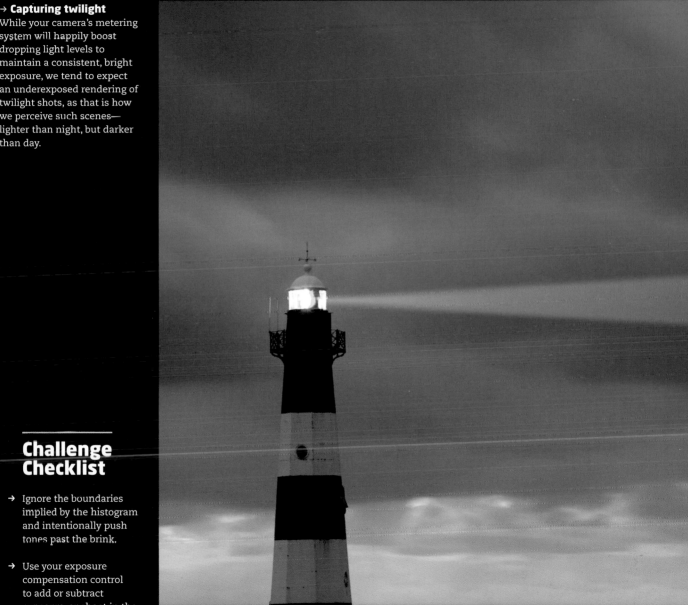

→ Capturing twilight

While your camera's metering system will happily boost dropping light levels to maintain a consistent, bright exposure, we tend to expect an underexposed rendering of twilight shots, as that is how we perceive such scenes—lighter than night, but darker than day.

Challenge Checklist

→ Ignore the boundaries implied by the histogram and intentionally push tones past the brink.

→ Use your exposure compensation control to add or subtract

Review

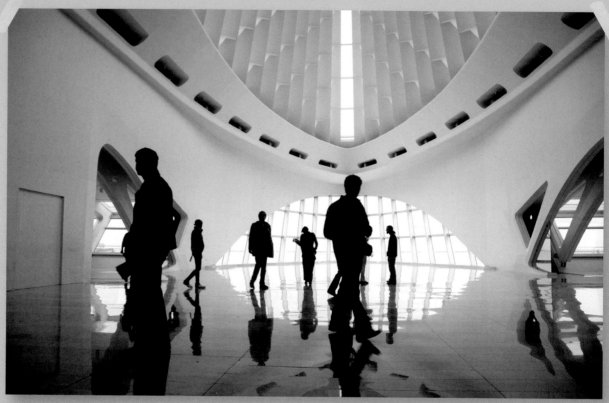

© Nathan Biehl

By exposing for the white walls of the hall's architecture, the figures fall into shadow as the light from outside becomes a brilliant white. f4 at 1/50 second, ISO 200 with +1/3 exposure compensation.
Nathan Biehl

An excellent example of deciding what the important tone is, and exposing for that. The white walls are indeed the key to everything here, and they need to be exactly as you have them—light but not fully white. And the exterior white looks, as you say, brilliant rather than overexposed.
Michael Freeman

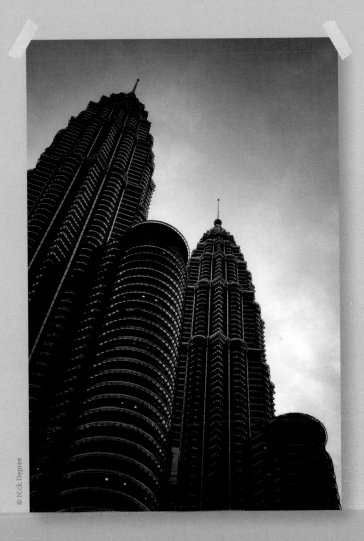

© Nick Depree

Petronas Towers, Kuala Lumpur. I
underexposed the shot to give a dark
tone and a different feel to the very
recognizable landmark, which came
out dark grey instead of the bright
stainless steel normally associated
with the towers. f5.6 at 1/320
second, ISO 800.
Nick Depree

This makes a good pairing with the
picture opposite, as it too has above
all a good *reason* for being exposed
less than would be expected.
The Petronas Towers are indeed
overexposed in another sense, so it's
a good decision to go for a different
and more eye-catching treatment.
Michael Freeman

ISO Speeds

The ISO setting on your digital camera provides enables you to adjust the light sensitivity of the image sensor. Just as with film, the higher the ISO (the acronym stands for International Standards Organization) number, the more responsive the sensor is to light; and the lower the setting, the less sensitive it is. In bright light, therefore, you can use a lower ISO number and get a good, clean response; but if you find yourself shooting in a dim lighting situation (indoors by existing light, for example), you can raise the setting to increase the sensitivity of the sensor's response. So why not always use a high ISO? Because it comes with the price of noise, and so the highest image quality goes hand in hand with the lowest ISO.

Most digital cameras have both an automatic ISO mode and a manual setting. In the auto mode, the camera will evaluate the amount of ambient light and set the ISO speed for you. The auto setting is useful if the ambient light is changing quickly—ducking in and out of historic buildings, for example—and you don't want to be bothered changing the setting every few minutes. In the manual mode, you have to make an assessment of the existing light and then set the ISO setting based on your own judgement. Also, all cameras have a default settings (typically ISO 100 or 200, depending on the camera model) that provides optimum image quality when there is an abundance of existing light.

The beauty of having a variable ISO setting is that you can change it for literally every shot. In the film days, changing the ISO setting meant changing an entire roll of film. With a digital camera, however, you can be shooting at a low ISO setting in bright sunlight one moment and then switch to a faster setting when you head indoors to shoot by a very low level of existing lighting.

One important fact to keep in mind is that the sensitivity response of your sensor doubles each time you double the ISO. If you switch from the default setting of ISO 200 to a setting of ISO 400, for example, you double the sensor's response to light. Similarly, each time that you halve the ISO number you cut the sensitivity in half. And, as we'll delve into more in the coming pages, doubling (or halving) the camera's sensitivity can have significant technical and creative benefits in terms of specific exposure settings.

ISO settings typically range from about ISO 100 to ISO 3200 or 6400 in most consumer-level DSLR (and advanced zoom) cameras, with much higher settings in pro-model DSLR cameras. Top-end professional models now boast a maximum setting in excess of ISO 200,000—presumably for photographing fast-moving black panthers in the jungle on a moonless night.

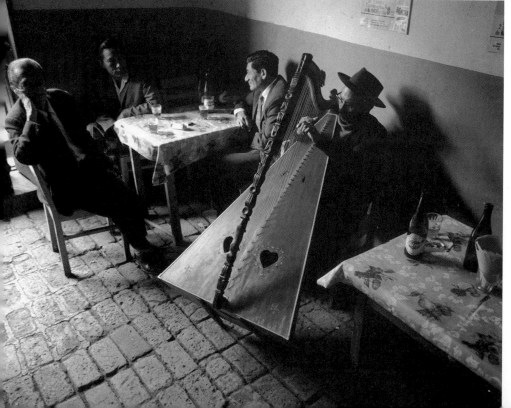

← A more sensitive response

By raising the ISO speed, your camera responds better to low-light situations and avoids the necessity of turning on flash, which can destroy the mood of intimate scenes like this cafe.

↑↑ The price of speed
The price of increased sensor
speed is an increase in image
noise. It's a price worth paying
if it means getting a shot you
would otherwise lose.

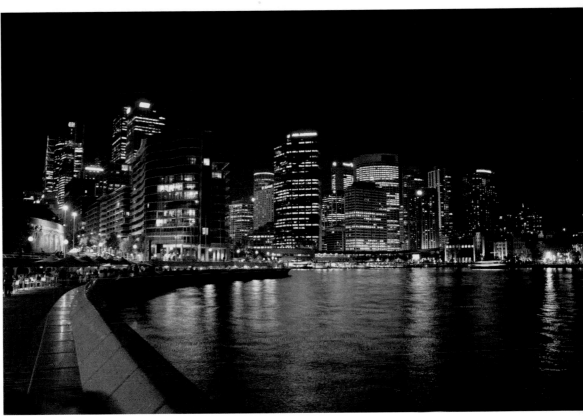

© Daniel Seidel

ISO and Image Noise

The flexibility of being able to adjust the ISO sensitivity of your sensor does not come without a certain (albeit small) technological price—namely that of what is called digital noise. Noise is a random textured pattern that interferes with the image (reminiscent of the graininess of high-speed films, though caused differently) that occurs when you use an excessively high ISO speed. The actual amount of noise depends on several factors including the size and design of the sensor, and whether you've tried to pull up shadow detail in post-production. In general, however, the higher the ISO and/or the smaller the physical size of the sensor, the more likely you are to see objectionable noise.

Technically, noise is the result of electrical interference (often called "cross talk") between the photosites (pixels) on a sensor, and the more photosites there are on the sensor, the greater the noise. That is why smaller sensors that have more pixels typically produce more image noise than larger sensors. Larger sensors enable the pixels to be spaced farther apart and allow for greater isolation or filtering of their signals. The reason that noise increases at higher ISO speeds is because the analog-to-digital converter in your camera is magnifying the signal from each photosite, and that in turns magnifies the electrical interference that results in visible noise.
Just how distracting noise is in an image is really a matter of personal taste, and also depends on the size of

↑ Into the night
It is important to keep perspective when evaluating your image for noise levels. What looks like a grainy mess at 100% magnification, may be perfectly fine at a reasonable viewing distance. Additionally, noise reduction is a powerful post-production tool that can often salvage shots, provided you have the time.

the enlargements that you intend to make. In general, however, you are better off with using the lowest ISO setting that will provide the aperture and shutter speed combinations that you require for a particular situation. Manufacturers continue to make great strides in reducing noise and increasing the range of available ISO speeds, and most often the ability to shoot pictures in extremely low-light settings far outweighs the minimal distraction of a small amount of noise.

Challenge

Get the Shot with a High ISO

↓ Not quite pure black
Concerts in dark venues are a classic high-ISO scenario. Fortunately, the subject is often rather accommodating of a grittier, noisier rendering, as it suits the visceral feeling of such scenes.

Unless you're photographing troglodytes in the deep recesses of a subterranean sunless world, today there are few subjects that you can write off because there isn't enough existing light. With ISO speeds of 1600 and 3200 common and with some cameras boasting speeds up to the 200,000 range, you can pretty much always find a way to expose even the dimmest of subjects. There are, of course, prices to pay for such speeds, namely an increase in image noise and a related softening of details and natural textures.

But considering the ability that such an extended ISO range gives you to record subjects that seem nearly devoid of ambient light, those are small prices to pay. And so for this challenge, take a look into the nighttime world or into the realm of dim interior spaces and use your highest ISO settings to wrest properly exposed images from them. Try most of all to bring back images of subjects that you thought were beyond capturing: city streets at midnight, the unlit interior of a cathedral, or your favorite band in the local basement pub.

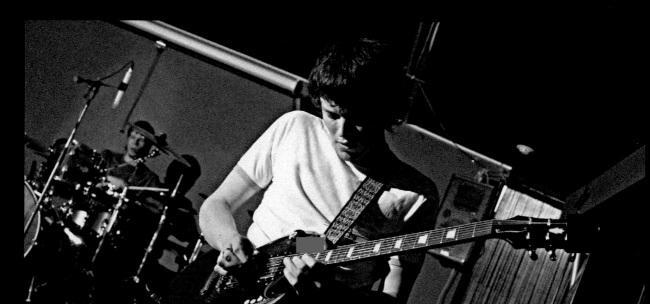

→ ISO as a failsafe

This shot required a fast shutter speed for a sharp shot (considering both the moving subjects on the ground and the long focal length of the lens used) and also a sufficiently narrow aperture for the depth of field to stretch from foreground all the way to the horizon. Add in the dropping light levels of dusk, and a high ISO (1600) was the only way to adequately capture the shot.

Challenge Checklist

→ Remember that each time you double the ISO speed, you are doubling the amount of light that reaches your camera's sensor. Doubling the ISO then has the same effect as opening the lens a full stop or slowing the shutter a full stop.

→ Often metering in very dim locations is less reliable than just raising the ISO incrementally and viewing your results on the LCD. The trick is to find an ISO speed that will record adequately without image noise becoming obvious and oppressive.

→ Using a wide-aperture lens will help get more light to the sensor at the same ISO. If noise is a distraction, try shooting at a more moderate ISO with a wider aperture.

Review

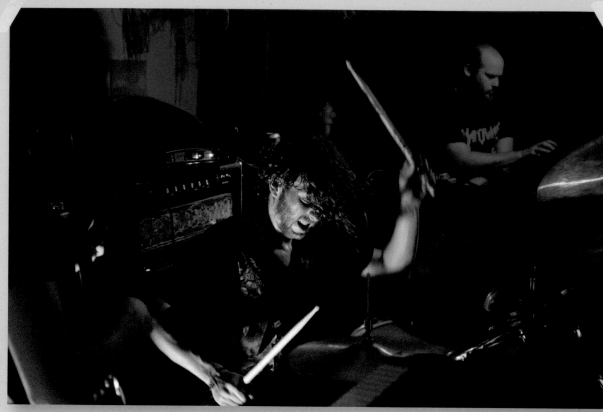

© Nathan Biehl

Lighting was minimal at the show and I was forced to shoot wide open with the ISO maxed to 6400. Luckily, a small lamp was able to briefly illuminate the drummer. f1.8 at 1/50 second, ISO 6400.
Nathan Biehl

I'm not sure from what you say whether you added the small lamp yourself, but however it appeared, it adds both color contrast and focuses attention on the key action. The shutter speed was sufficient to hold the drummer's face sharp, so the blur of the left hand is completely acceptable.
Michael Freeman

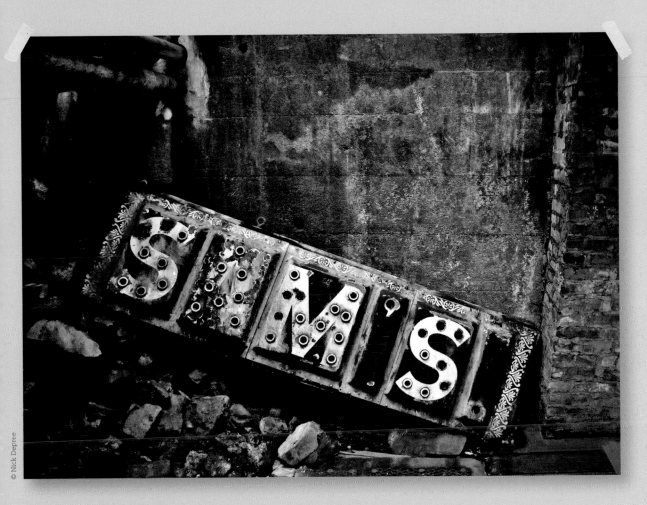

Under Pioneer Square, Seattle. The very dim tunnels under old Seattle required both ISO 3200 and bracing myself against a doorway to get a sharp shot with a slow zoom lens. f3.5 at 1/5 second, ISO 3200.

Nick Depree

Was f3.5 the maximum aperture of your lens? In any case, its depth of field is sufficient for all except the top left corner pipes. A fifth of a second braced is good camera handling, and I imagine you work on your hand-holding skills—which is good practice for low-light shooting.

Michael Freeman

Lens Apertures

Regardless of whether you are using a simple compact digital camera or a sophisticated DSLR camera, the purpose of the lens aperture is exactly the same: to regulate the amount of light that is allowed to pass through the lens to the camera's sensor. The size of the aperture is referred to as the f-stop and is controlled either electronically or, on older lenses, by a mechanical ring on the lens known as the aperture ring. In simplest terms, the larger the aperture opening is, the more light that gets into the camera and onto the sensor; and the smaller the opening, the less light that reaches the sensor. If you were to close the lens aperture entirely, of course, no light would reach the sensor at all; and at the other end, there is a limit as to how wide a lens can open (its "maximum aperture"). That maximum aperture is different depending on each lens, and with many zoom lenses, the maximum aperture is variable, meaning that it will narrow as you zoom in closer and reach into longer focal lengths.

In order to be able to use lens aperture to control either exposure or focus, it's important that you have a sound understanding of how the f-stops are numbered and why. In fact, the more that you understand about the f-stop numbering system, the simpler the concepts become. The available number of full and partial f-stops on a given lens (or the electronic options for those settings provided by the camera) will vary by lens brand/model and by the camera's exposure system, but all lenses use the exact same sequence of full f-stops, illustrated along the bottom of these two pages.

The concept is far simpler to understand if you think of the aperture numbers as multiples of each other. Each f-stop in the sequence allows double the exposure of its neighbor on one side, and half the exposure of its neighbor on the other. This is why the numerical sequence looks a little strange at first—because it's a logarithmic sequence, with bigger

apparent leaps between numbers the higher up you go. So, while the difference between 1.4 and 2 may look smaller than that between 11 and 16, in fact both steps are the same—halving the amount of light allowed through the lens. That sounds complicated only because you shouldn't think of f-numbers as a normal, numerical sequence. All you need to do is acquaint yourself with the standard f-stop sequence and you'll be ready to shoot with any camera.

↓↘ **Larger numbers = smaller openings**
If there's one concept you should take away from these pages it's that the larger the f-number is, the smaller the opening is, and vice versa. If you want to let in more light, switch to a larger opening—i.e., a smaller number.

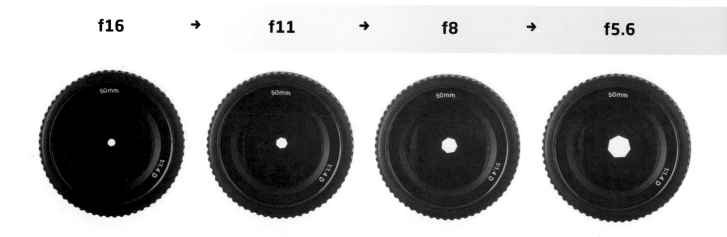

f16 → f11 → f8 → f5.6

Controlling Depth of Field

In addition to its purely exposure-driven purpose of regulating the amount of light that reaches the sensor, the aperture also controls how much of the scene is in focus. When you focus your lens, you are moving a single, 2-dimensional plane of ideal sharpness closer to and farther away from the sensor. However, the vast majority of subjects are three-dimensional, extending in front of and behind that ideal plane of focus, and in order to capture them sharply, you likewise need to expand that plane into a three-dimensional zone of sharp focus.

The name for that zone is the depth of field, and it is directly controlled by the aperture: The wider the aperture (the lower the f-number), the shallower the depth of field; and the narrower the aperture (the higher the f-number), the deeper the depth of field. Use a narrow enough aperture, and you can fit everything in front of you in focus, from the foreground all the way to the horizon line. Use a wide enough aperture, and you can sharply isolate a portrait subject against a soft, blurred, out-of-focus background, concentrating attention only on what is important.

→ Pick your plane of focus

Changing your aperture will affect much more than just your exposure, and you must always be mindful of how much or how little depth of field a given aperture value will give you, and ensure that it is appropriate for your particular subject. In this shot, you can see that the bouquet of roses, situated midway into the scene, is sharp and in-focus, while the ropes extending in front of and behind the bouquet gradually fall out of focus in either direction. That is because a wide aperture (f2) was used to create a shallow depth of field, and the lens was then focused to position the bouquet precisely within this depth of field, allowing the peripheral elements of the scene to fall off into the out-of-focus areas.

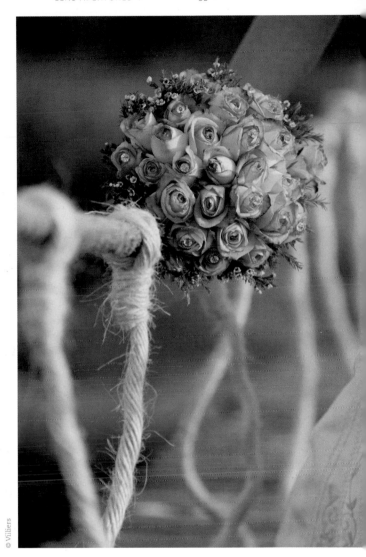

© Villiers

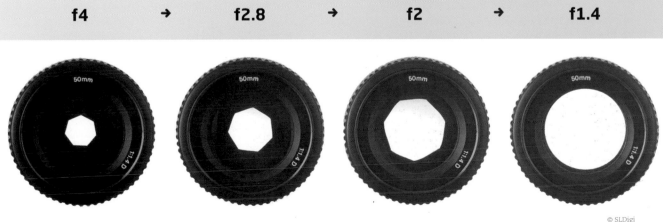

| f4 | → | f2.8 | → | f2 | → | f1.4 |

© SLDigi

The Math Behind the Numbers

© Ikunl

© Gudellaphoto

↑ Consider the side effects of aperture
In order to slightly underexpose this scene (so that the trees are rendered as silhouettes), a narrower aperture was used—which also extended the depth of field throughout the shot.

← Know when to take your time
With static landscape shots, time is often on your side, and you will be able to experiment with a variety of different exposure settings.

Let's look in a little more detail at the relationship between numbers and size of aperture. The f-stop numbers represent the ratio of the physical aperture diameter to the focal length of the lens. For example, if you're using a 120mm lens and you're using an aperture of f4, then the physical size of the aperture is 30mm or one-fourth of 120. If you moved to a larger aperture (again, a smaller f-number) such as f2, the size of the lens aperture would be 60mm (because 60mm is one-half of 120mm).

You can easily figure the actual diameter of the lens opening by simply dividing the f-stop number into the focal length of the lens. If you're using a 300mm lens set at f4, for example, the diameter of that f-stop is 75mm (4 x 75=300). If you switch to f2, the diameter is 150mm (2 x 150=300). Now think about which aperture is larger and which will let in more light.

To visualize this, imagine looking at your lens opening sideways: If you were using a setting of f2 it would fit exactly twice from the center of the front lens element to the focal plane (the sensor plane) of the camera.

Stops Versus f-Stops

Before we continue with our discussions of exposure, it's important to clarify that while f-stops refer to apertures specifically, "stops" is often used to refer to exposure more generally, and relate equally to ISO, aperture, or—as you'll see on page 40— shutter speed. So, when you hear that exposure is decreased "by three stops," this can mean a narrow aperture was set, but it can also mean a lower ISO or a faster shutter speed was used. In terms of the final exposure, there is no difference: the amount of light reaching the sensor has been decreased.

Aperture Changes and Exposure Changes

One very significant bit of aperture math that it's important to understand is that each time you shift from one f-stop to another f-stop that is either a whole-stop larger or a whole-stop smaller, you either double or halve the amount of light reaching the sensor. Suppose, for example, when you shift from a setting of f8 to f5.6 (an opening that is one whole-stop larger), you are doubling the amount of light that reaches the sensor. If you were to "close" the aperture by one stop and change from f8 to f11 (again, that's a change of one full stop), you would cut the mount of light reaching the sensor in half.

As you may remember from our discussion of ISO speeds, the exact same relationship exists when you change between apertures. If you set twice as wide an aperture, you double the amount of light reaching the sensor. If you halve the aperture, you halve the amount of light. So, for example, if you change from a setting of f2.8 to a setting of f2, you double the light reaching the sensor. But if you cut the f2.8 aperture down to f/4, you cut the amount of light being gathered in half.

The doubling and halving of exposures occurs with each of the three exposure controls, including shutter speed—as you are about to learn—and is of course deliberate, making it easier and more practical to juggle the three settings. In other words, the relationship between the three controls is reciprocal. Though it may take some getting used to at the start, once you understand it you will rejoice in its simplicity, and exploit it for consistent, accurate exposures.

© Mat Hayward

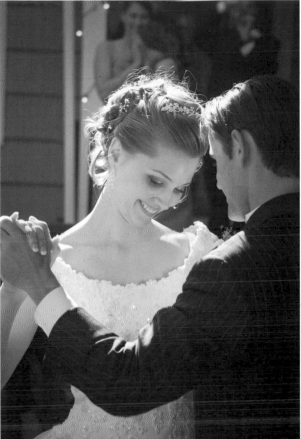

← An elegant relationship
Aperture and the amount of light reaching the lens have a profound relationship that is both simple and elegant: open the lens by one stop, the light doubles, close it by one stop, the light drops by a half. In order to maintain a consistent exposure, you must compensate for the f-stop changes with either an ISO or shutter-speed adjustment.

↓ Making radical changes
One of the things that an adjustable aperture allows is a rapid response to changes in the quantity of light. If you're working with an autoexposure mode (see pages 58–59), those changes will take place instantaneously.

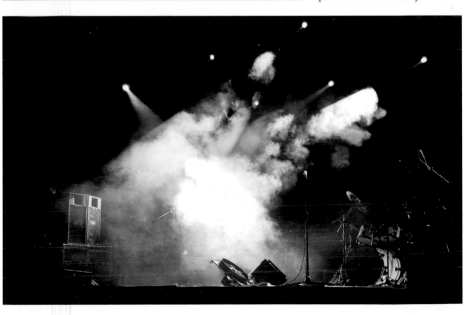

© Narcis Parfenti

Demonstrate Depth-of-Field Control

↓ Fitting it all in
When looking for maximum depth of field, focus about a third of the way into the scene, as the depth of field extends disproportionately in either direction away from the plane of focus: 1/3 of the total depth of field extends in front of the focused plane, while 2/3 of it extends beyond.

Once you understand the forces that control depth of field—aperture, focal length, and subject distance—you have almost perfect control over what is or isn't in a scene. You now know, for instance that by using a wide-angle lens and a small aperture, you can create images that are in continuously sharp focus from your toes to the horizon. And by reversing those factors and switching to a long-focal-length lens and a wide aperture, you can

restrict depth of field to as little as a few inches or less. How you manipulate depth of field for this challenge is unimportant, but you must demonstrate that you understand the fundamental controls and how to combine them to achieve your goal. But more than merely controlling depth of field, show that you can match it also to the appropriate subject: selective focus in a portrait, for example, or boundless sharpness in a rural landscape.

→ Blurred but visible

With careful composition, you can make even out-of-focus subjects a meaningful part of your shot.

Challenge Checklist

→ Remember that the higher the aperture number is, the smaller the lens opening and the more extensive the depth of field. If your shutter speeds get too long, be sure to mount the camera on a tripod.

→ Restricting depth of field in bright light isn't always possible because you may not have a shutter speed fast enough to allow wide aperture. But you can always add a neutral density filter to reduce the light entering the lens.

→ When using very shallow depth of field, be sure to focus carefully on that part of the subject you want in sharpest focus—the eyes in a portrait, for instance.

→ The depth of field preview feature of your DSLR will show you the scene at the shooting aperture, but you may have to let your eye adjust to the time view to see it clearly.

Review

© Richard Gottardo

For this picture I wanted to make the flowers really pop while keeping a simple outline of the woman against a simple background. This was achieved by setting an aperture of f1.4 on a canon 50mm f1.4 lens and placing her in front of a small pond with no distracting elements in the background.
Richard Gottardo

You're fortunate to have such a lens—f1.4 is one of the fastest available, and this is certainly the way to make the most use of it, at full aperture and with good front-to-back depth to exaggerate the selective focus. The unfocused areas blend their pastel colors nicely.
Michael Freeman

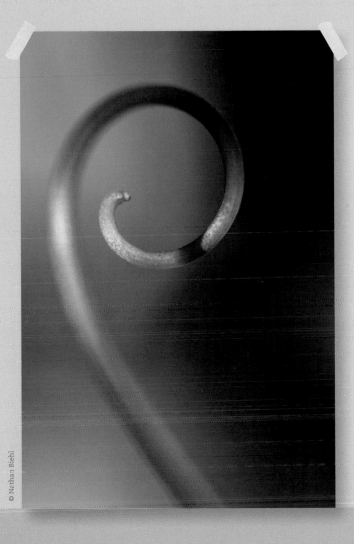

© Nathan Biehl

A macro lens provided the narrow depth of field required to isolate the tip of this tendril. Letting its stalk spiral out of the focus. f9 at 1/400 second, ISO 200, with -1/3EV exposure compensation.
Nathan Biehl

Good treatment, letting the spiral work itself out of focus. It looks as if you angled the tendril to maximize the sharp focus near the tip. I'm intrigued, though, to know why you set the aperture at a mid-setting of f9 rather than maximum aperture.
Michael Freeman

Shutter Speed

The third element in the exposure triad is shutter speed. Whereas aperture controls the amount of light that reaches the sensor, the shutter speed controls the duration of time that the sensor is exposed. As you might surmise, the longer the shutter is kept open, the more light that reaches the image sensor to build up the exposure. A good analogy for exposure length is that leaving your shutter open is kind of like leaving your garden hose running into your sink—the longer the faucet remains "open" the more water that fills the basin. Similarly, the shorter the duration of the exposure, the less light that hits the sensor (or water that fills your sink).

The Shutter Speed Sequence

The shutter-speed settings on your camera represent either fractions of a second (1/60, 1/4, 1/2 second, etc.) or whole seconds (1, 4, 8 seconds, and so forth). Some cameras also have shutter speeds that represent full minutes, as well. Your camera manual will list the full shutter-speed range and progression that your camera offers.

Because these shutter speed settings represent the actual amount of time that the shutter remains open, most of us find the concept of shutter speeds far simpler to understand than aperture designations. If you set the shutter at 1/125 second, for example, that's precisely how long the shutter remains open: 1/125 of a second. While most of us can't necessarily comprehend just how long such a brief exposure is, we can understand that it's certainly much more brief than an exposure of, say, 10 seconds. Unlike ISOs, with their exponential numbers-by-the-hundreds, and apertures with their logarithmic f-stops, shutter speeds work in the simple and straightforward measurements of time that we use every day.

↓ Frozen in time
Candid moments like this shared laughter require a fast shutter speed (and a keen compositional eye).

↓ Easy choices
When you're working with an unmoving subject, choosing a shutter speed is easy: you just need it fast enough to prevent camera shake; and even if a longer speed is unavoidable (such as being required by a night shot), you just need a tripod to steady your camera.

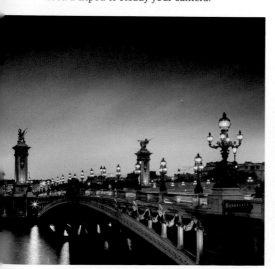

© Beboy

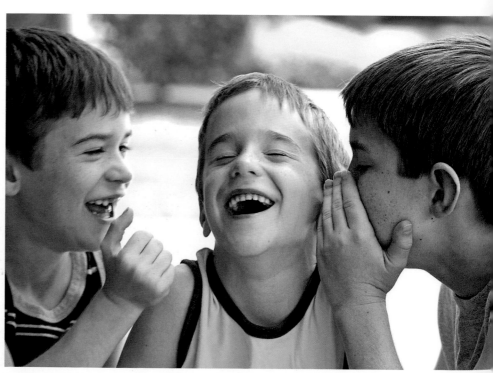

© Sonya Etchison

The Full-Stop Sequence

All cameras use a standard selection of shutter speeds that typically ranges from, say, 30 seconds or 60 seconds at one extreme to speeds as brief as 1/2000 or 1/4000 second at the other. Again, obviously, a shutter speed of 30 seconds is a much longer duration than one of 1/4000 second. In fact, one of the interesting things about the difference in shutter speeds is that you can actually hear the shutter opening and closing on most cameras, so detecting a long exposure from a short one is relatively easy. Try it.

Before electronics entered the world of camera design all cameras used a series of "whole" shutter speed increments that followed a standard progression such that typically included this group of shutter speeds:

example, you double the amount of time that the sensor is exposed to light. Conversely, as you move from 1/250 second to 1/500 second, you halve the amount of time that the shutter remains open.

Those of you who are paying close attention should begin to see a pattern here of either halving or doubling exposure—and we'll discuss that very special and perfect reciprocal relationship (that is the basis of all exposure settings) in the coming pages.

Since cameras became more electronic and less mechanical, this absolute progression of whole shutter speed stops has been tinkered with, because fractional stops have been introduced. Some cameras, for instance, have a shutter speed of 1/320 second that falls (roughly) midway between 1/250 second

and 1/500 second. While these new intermediary stops can be useful in fine-tuning shutter-speed response, to understand the mathematical theory of exposure, you will probably find it simpler to concentrate on the whole-stop sequence.

You might also find that many cameras also feature a shutter speed designated as "Bulb" and that setting allows you to keep the shutter open for as long as you like (the term is a quaint reminder that shutters in old cameras were activated hydraulically, by squeezing a rubber bulb). Once you press the shutter release button in the Bulb position, the camera's shutter will remain open until you press it again. This setting is particularly useful for long time exposures—taking night scenes of traffic, or capturing the light trails of stars, for example.

30 seconds ➜ 15 seconds ➜ 8 seconds ➜ 4 seconds ➜ 2 seconds ➜ 1 second ➜ ½ second ➜ ¼ second ➜ ⅛ second
1/15 second ➜ 1/30 second ➜ 1/60 second ➜ 1/125 second ➜ 1/250 second ➜ 1/500 second ➜ 1/1000 second ➜ 1/2000 second ➜ 1/4000 second

These shutter speeds are referred to as "whole" stops because as you progress from one shutter speed to the next, you either double or halve the amount of time the light has to enter the camera. As you move an exposure of 1/60 second to one of 1/30 second, for

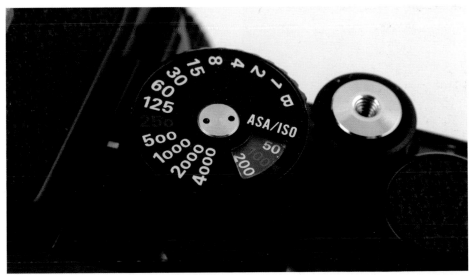

→ The shutter sequence
Though you're unlikely to see such a shutter speed dial on your modern camera, their presence on old film cameras was a testament to their significance in every shot.

Aperture & Shutter Speed: The Reciprocal Relationship

As we noted, the "whole" steps up or down in both aperture and shutter speed have a similar effect on the exposure. If you make a change in one direction by a full stop in either shutter speed or aperture, you can maintain exactly the same levels of light being recorded on the sensor if you make an equal but opposite change in the other setting. This reciprocal relationship, in fact, is the basis for all changes in exposure settings.

↓ You control the focus

Here the photographer opted for a wide aperture to limit depth of field—an option that suits the subject by making her stand out in relief against a blurred background.

Let's assume, for example, that you meter a scene and the camera tells you that the ideal exposure setting is 1/125 second at f8. But what if you want to use a faster shutter speed of 1/500 second to stop fast action? That's an increase in shutter speed of two full stops. If you were to leave the aperture at the same f8 setting, the image would be underexposed by two stops. But if you were to open the lens by two stops to f4 (to allow in more light) you would

↓ Extending your depth of field

By choosing a small lens aperture and adjusting the shutter speed accordingly, the photographer was able to exploit almost infinite depth of field in showcasing the foreground of the Taj Mahal.

get the exact same exposure. (Look at the aperture sequence on pages 32–33 and you'll see that f8 to f5.6 to f4 is two stops.)

This relationship works in the opposite direction too, naturally. If you were given a meter reading of 1/125 second at f4, but wanted to shoot at an aperture setting three stops smaller (f11), to get more depth of field, you could simply set that aperture and slow the shutter by three stops. The equivalent setting would be 1/15 second at f11. Again, the full-stop sequence for slowing down shutter speeds would be: 1/125 to 1/60 to 1/30 to 1/15 second, or three stops.

This perfect reciprocal relationship lies at the heart of not just exposure, but photography in general. Metering a scene (as explained on page 62) is one thing, but recognizing the full range of possible ways to interpret your exposure, through shutter speed, aperture, and even ISO, cuts straight to the creative side of taking pictures.

© Julia Shepeleva

© Martin M303

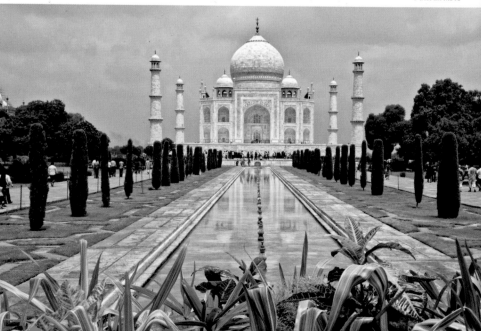

Beware the Consequences

As you make shifts in either the aperture or shutter speed settings you must remain aware that such changes can create significant visual changes. As you switch to a faster shutter speed and increase aperture size, for example, you are not only letting more light through the lens but you are changing the depth of field for the shot. If depth of field is an important consideration for the shot, this must be taken into account. If on the other hand you were to use a smaller aperture and had to slow the shutter speed to get an equivalent amount of light into the camera, you might have to take into account changes in how subject motion (if any) is recorded.

Last Resort: Change the ISO

What happens if you want to increase the shutter speed by, say, two full stops but don't want to open the lens because of you want to maintain the same level of depth of field? The only solution in this case would be to raise the ISO setting by two stops. By raising the ISO two full stops (as an example: 200 to 400 to 800, or two stops) you could maintain the same aperture and still raise the shutter speed by two stops.

→ **Cause and effect**

As you scroll through various combinations of shutter speed and aperture you must remain aware that certain aspects of a scene will change with each pairing. In a scene like this seascape, either the depth of field or the motion of the water will be affected by exposure changes—or both.

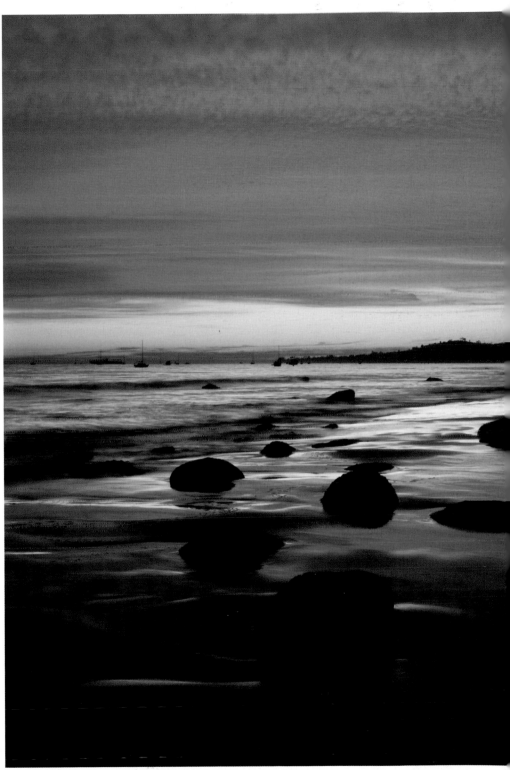

© David M Schrader

Capturing Motion

All digital cameras feature one of two types of shutters. Most compact and point-and-shoot cameras feature an inside-the-lens, leaf-type shutter that opens and closes like the iris and pupil system that your eye uses to control the flow of light. When you press the shutter-release button, the iris instantaneously opens and then closes again. The length that the iris remains open is based on the shutter speed that you have selected. The iris in this type of shutter is shaped very much like the lens aperture opening and, in fact, is usually placed immediately adjacent to the lens aperture.

Most DSLR and other interchangeable-lens cameras, on the other hand, use what is called a focal plane shutter that consists of a curtain placed directly in front of the image sensor. When you press the shutter release the curtain opens, light hits the sensor (though in a DSLR a small amount of light is also deflected to focusing sensors in the base of the camera) and when a sufficient amount of light has reached it, the shutter curtain closes. All of this, of course, happens in the mere blink of an eye at speeds frequently measure in just thousandths of a second.

Shutter Speed and Motion

In addition to controlling the length of the exposure, the shutter speed that you select also has a significant effect on how moving subjects are recorded. Whether your goal is to freeze fast-action subjects so as to reveal every nuance and detail of a sports moment, for example, or to turn subjects in motion into surreal abstractions, there is a shutter speed available to do the job. Learning to control, arrest, or exaggerate motion is, in fact, one of the most fun things about owning a camera with an adjustable shutter speed.

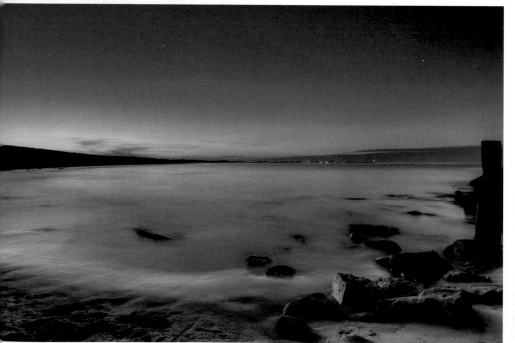

© Chris Leachman

← The flow of time

One of the fascinating aspects of being able to adjust shutter speeds is that you can use long exposures to record the patterns of motion that otherwise go unseen—as shown here in this time exposure of the ebb and flow of the tide.

↓ Streaks in the night

By using a combination of a long shutter speed and a fast-moving light source you can transform ordinary moments into dynamic and wonderfully abstract images.

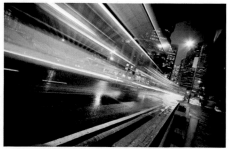

© Konstantin Sutyagin

Freezing Motion

We've all flipped through the pages of sports magazines and marveled at brilliant shots of galloping horses seemingly levitating in mid-air, or high-diving Olympians frozen in a spray of diamond water droplets as they rip the surface of a pool. These photos are the result of two things: photographers with an impeccable sense of timing; and very fast shutter speeds. Amazingly, the ability to capture such shots (impeccable timing requirements aside) is available in any camera with an adjustable shutter-speed setting. The standard fast shutter-speeds of 1/2000 or 1/4000 second are more than enough to stop even the fastest subjects in their tracks.

The specific shutter speed required to arrest a moving subject depends on many factors, not the least of which is the subject's speed. The faster it's moving, of course, the faster the shutter speed that you'll need to freeze the action. While you might be able to get a pretty good freeze-frame of one of your kids leaping over the dog using a shutter speed of 1/125 or 1/250 second, for instance, stopping a subject like race horse might take a very fast setting of 1/2000 or faster. The ability to stop action at a given shutter speed (at a given ISO), however, is also extremely dependent on a variety of other factors, including the way in which a subject and its parts move, how much of the frame it occupies, and whether it's moving across your field of view or toward you. Consider, for instance, that a car and a bicycle may be moving at the same velocity, but the car moves as one single subject, whereas the bicycle has a faster overall movement when you consider the cyclist's legs and pedal motions, which require a faster shutter speed to freeze.

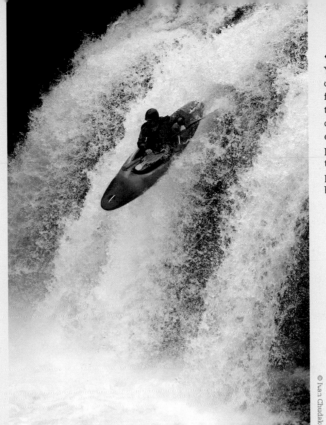

© Ivan Chudakov

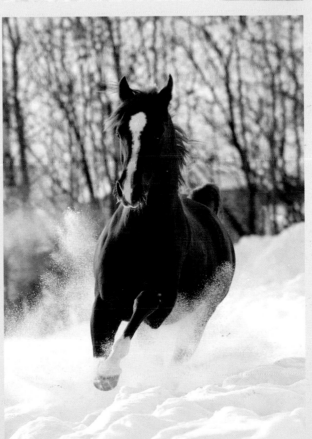

© Viktoria Makarova

← The blink of an eye
Your camera's shutter is capable of freezing even the fastest subjects and revealing them with a level of detail we could never see with the naked eye. In this scene of a kayaker plunging over a waterfall every tiny droplet of water is fixed in place and the kayaker seems to be levitating above the water.

← Anatomy of a moment
Photographers have been fascinated with the camera's ability to stop action since cameras were first invented. In fact, in 1877 British photographer Eadweard J. Muybridge used a fast shutter to prove that a running horse does lift all four hooves off the ground at one time while trotting. As this photo shows, photographers are still keenly obsessed with a horse's running patterns.

Direction of Action

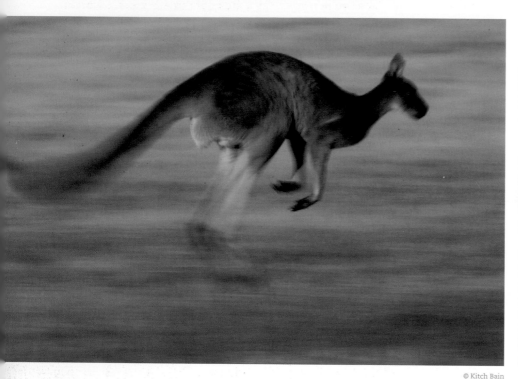

© Kitch Bain

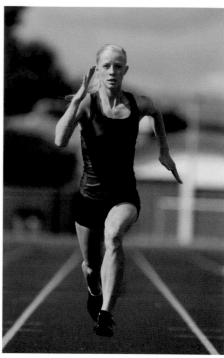

© Sly

Action that is coming toward or going away from the camera can be stopped at significantly slower shutter speeds than action that is crossing your path. If you are capturing runners coming around a track, for example, it's easier to completely arrest their motion if you position yourself at a curve in the track and shoot facing the action so that the runners are either heading into your lens, or receding away from it. It may take a shutter speed up to three or four times faster to stop a subject moving across your path as compared to one moving toward or away from you. If a subject moving toward you was frozen at 1/250 second, for instance, you might be required to shoot at a 1/2000 second to stop it if it were moving parallel to your camera.

↑ Parallel action = faster speeds
Motion moving side-to-side across your field of view requires the fastest shutter speeds to fully arrest. Often a better solution is to use a moderately slow shutter speed and pan with the motion.

Why is this so? Because a subject traveling across your path will spread itself across the sensor—as it does on the retinal surface of your eyes—more during any given slice of time than a subject moving toward or away from the sensor. More of the pixels on the sensor are simply being exposed to more of the motion. This is exactly why it's harder for your eyes to focus on and sharply render a racecar moving side-to-side in front of you than one that is heading directly at you.

↑ Perpendicular action = slower speeds
If you want to completely stop action, position yourself so that the subject is coming directly at your lens (or moving away from it). This shooting angle does, however, require a fast-response focusing system.

Subjects that are moving diagonally, either toward or away from the camera, can usually be photographed at shutter speeds that fall between those required for a subject either moving toward/ away from the camera or one moving parallel to it.

Subject Distance and Focal Length

The distance between camera and subject also has a major effect on your ability to stop action in a photograph. The closer that you physically are to a subject, then the faster the shutter speed (relatively speaking) that is required to get an acceptably sharp image of it. Try standing beside a highway (or on an overpass) some afternoon and watch distant cars traveling at a high rate of speed. It's fairly simple for your eyes to focus on the cars that are quite a distance away. But then try to focus your eyes on the cars traveling at the same speed as they pass right in front of you—it's a much harder task. In fact, if you're standing close enough to the cars and they're moving fast enough, you may not be able to focus on them at all.

It's very easy for your eyes to focus on the distant cars because, relatively speaking, their distance makes them appear to cover very little geographic territory compared to those cars immediately at hand. You might be able to get a sharp photo of a distant car traveling at, say, 100 mph with a relatively slow shutter speed, but it might take a shutter speed of several times that to stop a car going at the exact same speed when it is much closer to you.

Of course, the issue of your distance to the subject has to take into account the focal length of the lens you're using. If you're using, say, a 50mm "normal" lens (that has approximately the same viewing angle as your eyes) and standing 75 feet (23m) from the subject, then subject distance is pretty much a non-issue. But if you move to within 25 feet (7.5m) of your subject—even with a normal lens—your distance will become more of a factor in stopping action. You've effectively made the subject three times larger by cutting your distance to one-third. It may not be a dramatically significant factor, but you will probably need to increase shutter speed to stop the action.

But even if you kept your distance constant and increased the focal length by a factor of three to 200mm (50mm to 100mm to 200mm) then you are still effectively three times closer to your subject. You would have to make the same shutter speed correction as if you have moved closer. If you were to go to a lens of 400mm or longer, the change would be far more dramatic and you would certainly have to move to a higher shutter speed to maintain the same action-stopping power that you had with a normal lens.

Lens focal length plays a key roll in stopping action subjects because, as with moving closer, the longer the focal length of the lens, the larger the light image will be on the sensor.

→ The peak of action
Every type of action has a peak instant when all motion seems to stop for a brief instant. In this shot the exposure was timed to capture the perfect extension of the birds wings.

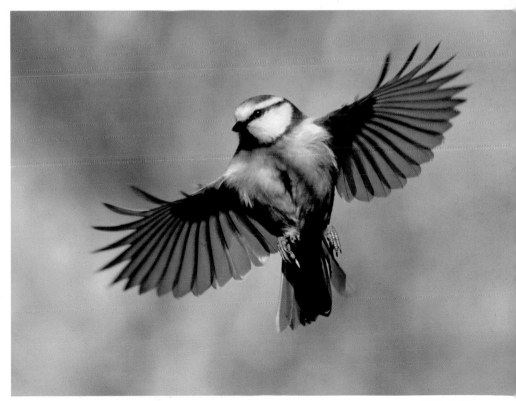

Challenge

Freeze the Action with a Fast Shutter Speed

↓ Catching the moment
Fast-moving subjects are going to push your autofocus system to its limits, but with sufficient light, you can narrow the aperture to increase the chance that the subject will fall within the depth of field.

One of the most amazing aspects of being able to adjust the shutter speed is being able to use very brief shutter speeds to completely stop even the fastest subject motion. This challenge will not only test your knowledge of shutter speed settings and how they relate to moving subjects, but also demonstrate your understanding of the nature of action subjects. You'll need to remember, for instance, that subjects coming toward or going away from the lens are easiest to stop with moderate

shutter speeds and those moving parallel to your sensor require faster shutter speeds. You will need to experiment with various subject and shutter-speed combinations and compare results to see what the minimum speed is for stopping action completely. And lastly, you'll need to know where to look to find subjects that are worth of this challenge—and that test your skills as an action photographer. Where will you look? How will you get close to the action?

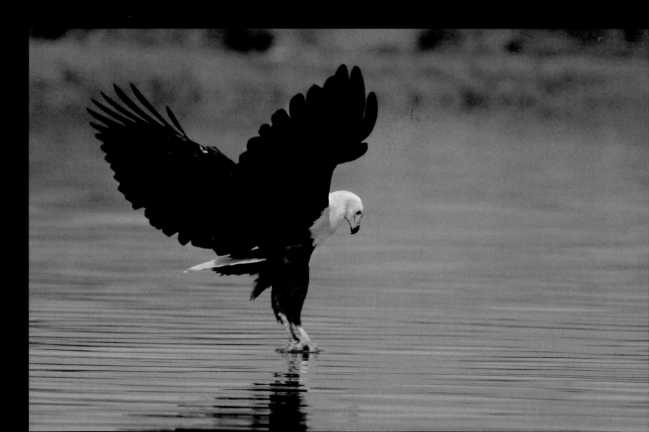

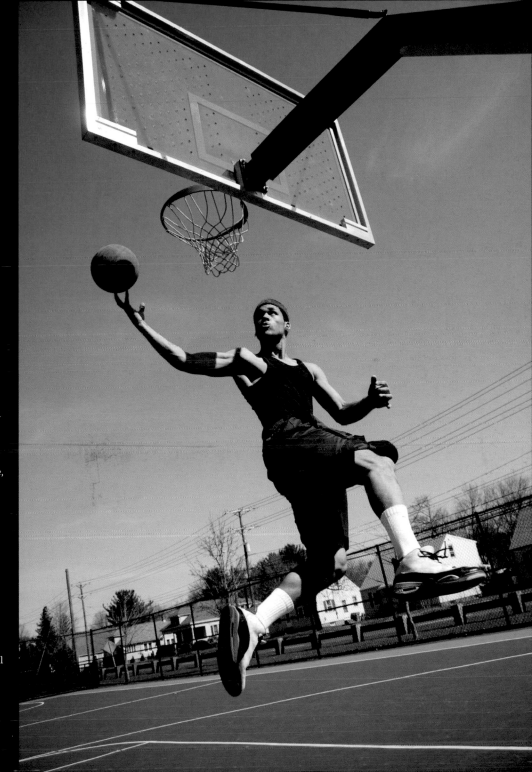

→ Make them come to you

The climactic moments that make the best action shots can often be predicted, giving you time to move into an ideal position and test a few exposures while waiting for the action to come to you.

Challenge Checklist

→ If you can find a subject that repeats the same motion over and over again (a friend swinging a golf club, perhaps), run a test of several shutter speeds to determine which is the slowest speed that will still freeze the action.

→ Remember that the larger the image is on the sensor the faster the shutter speed you will need to get a sharp image, so as you zoom out to a longer focal length you'll need to increase shutter speed.

→ Approach your action subject from several angles to demonstrate for yourself how the direction of the action changes your ability to freeze motion.

→ Don't forget the reciprocal nature of ISO and shutter speed: if you need to boost the shutter speed by one stop, just double the ISO. If you want to go two stops faster, double it again.

Review

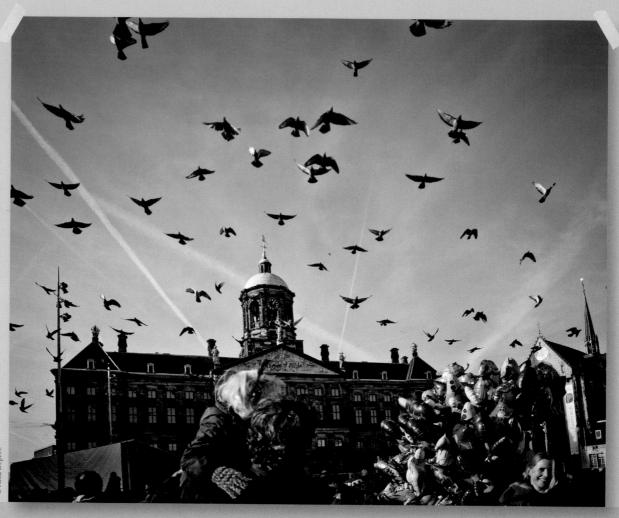

© Nick Depree

Dam Square, Amsterdam. Shooting in bright sunlight gave a shutter speed of 1/1600 second—more than fast enough to freeze the flock of pigeons as they flew overhead. f5.6 at ISO 400.
Nick Depree

Most birds-in-flight shots show some degree of motion blur in the wing tips, so it's interesting to see a completely frozen image here, and I imagine that's why you set the ISO higher than normal at 400. Good timing, as well, with the birds quite evenly distributed and more or less filling the sky.
Michael Freeman

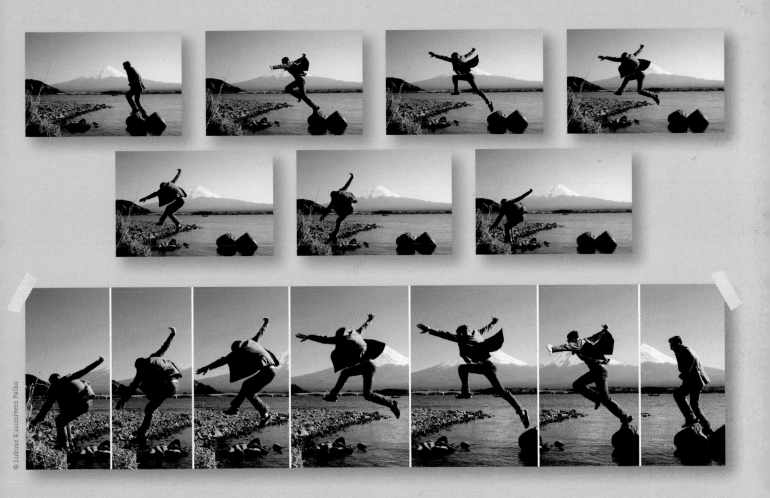

© Lukasz Kazimierz Palka

I set the aperture manually to f8 to create a DOF roomy enough for the jumper to stay in focus throughout his epic maneuver. This also ensured a shutter speed of 1/640 second in the bright sunlight. ISO 200.
Lukasz Kazimierz Palka

From the precision of the framing in the sequence, it looks as if you used a tripod. In any case, the action was well-planned, with an effective framing and sufficient room in the sky to allow for waving arms. Was this a one-off, or did you shoot it a few times?
Michael Freeman

Intentional Motion

As useful and fun as increases in shutter speed are, there are also times when exaggerating motion is the more creative path. If you're photographing carnival rides at night, for example, while it might be possible to freeze their motion with a high-enough ISO setting, what would be the point? The beauty of a Ferris wheel is the fascinating mixture of light and motion, and you can capture that magic in some fascinating ways by intentionally slowing the shutter speed. There are a few ways to employ longer-than-normal shutter speeds to exaggerate motion:

Moving Subject/ Stationary Camera

You can use a tripod-mounted camera and long shutter speeds to add an element of motion to everything from waterfalls to race horses to star trails in the night sky. In such situations, the actual shutter speed is largely a matter of experimentation and how daring you're willing to get with the motion. In the scene of the waterfall here, for example, a 4-second exposure at f22 was used to turn the motion of the water into a flowing effect.

Stationary Subject/ Moving Camera

Another fun way to exaggerate motion, particularly with nighttime subjects, is to intentionally jiggle the camera. To get these swirling colors of fairy lights on a Christmas tree (below, left), the shutter speed was set to two seconds, and the camera was randomly swirled around for the duration of the exposure. You can also create a related fun effect by zooming a lens during a long exposure to create a motion-like blur of a stationary subject.

© John Casey

↑ Satin waters
Photographers often refer to shots like this as the "satin ribbon" effect. It's simple to create: Put your camera on a tripod, set a long shutter speed and let the water paint itself.

← Move to abstractions
When sharp subjects aren't a priority, you can experiment with very long shutter speeds and exaggerated camera movements. The unexpected results are part of the fun.

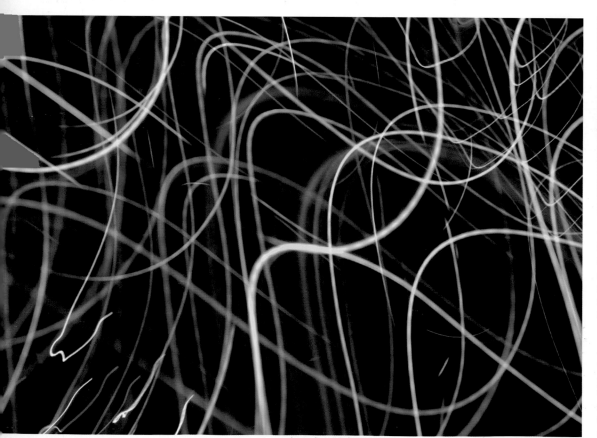

© Les Cunliffe

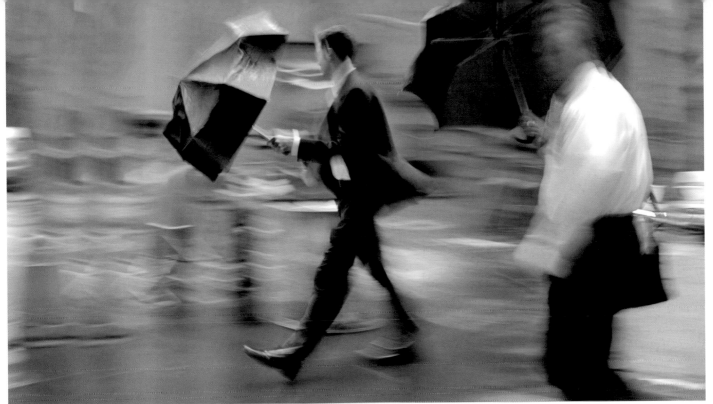

Moving Subject/ Moving Camera

Sports photographers often combine a long shutter speed with a moving subject and a moving target in a technique known as motion panning. By setting a relatively show shutter speed (typically around 1/4 to 1/30 second) and then follow-focusing on a moving subject—a downhill skier, for example), they are able to keep a relatively focused subject against a blurred background. The results look extremely dynamic and energetic, doing a great job of communicating movement. And as a bonus, it has a side effect of eliminating distracting backgrounds, as they are streaked into a blurred background that often contributes a welcome and strong graphic quality to the shot. It's a technique that takes some practice and shutter speed experimentation, but the results can be stunning.

Accidental Subject Motion

There is an inherent tendency to immediately reject a blurred shot as unusable. You remembered the scene sharply, and so you have certain visual expectations of how it should have been captured. Sometimes this is pure accident, as in you forgot to raise your shutter speed or widen your aperture as the lights dimmed; other times you are simply pushing the limits of your exposure, and the only way to capture the shot was to use a slightly too-long shutter speed. Plenty of times your first instinct to throw out the shot is correct: If it's a high-fashion portrait, meant to be reproduced in a high-quality, large print, certainly every element needs to be as sharp as humanly (or digitally) possible.

However, in less-demanding, personal work, such perfection is not always an absolute requirement. If the subject is

↑ Wild weather in motion

There's no rule written or implied that says that either the camera or the subject has to be stationary. Here, not only was a long shutter speed used, but the camera also kept pace with the motion to create a ballet-like swirl of umbrellas, feet, and traffic.

powerful, the composition is engaging, and the lighting is spectacular, these elements can come together to form a successful image regardless of the sharpness of the capture. Indeed, many classic and famous images from the past century rose above certain technical flaws because of the creative potential elsewhere in the image. This is not at all to say you should lower your standards and be sloppy with your technique, but I would encourage you to keep an eye out for diamonds in the rough, and not let technical perfection prohibit you from recognizing worthwhile keepers.

Blur the Motion with a Slow Shutter Speed

↓ Nothing left but trails
With sufficiently long shutter speeds, your images can easily take out an abstract, graphic quality—though it can be rather difficult to accurately predict the results.

Imagine a lazy stream tumbling gently down a shallow riverbed. Photograph it at a "normal" shutter speed of 1/125 second and that's just what you'll get: an average, normal shot of the water. But now reduce that shutter speed to a half second, or even a full second, and that same stream is transformed into a silver ribbon of satin water. Allowing motion to write its own story across your sensor using excessively slow shutter speeds is the polar opposite of freezing the action.

To succeed at this challenge, go forth into the world and find a subject that cries out to be interpreted slightly in the abstract, by exaggerating its motion. The stream is a familiar example, but there are other more hidden gems waiting to be recorded: the spinning of a bicycle wheel turned end up, perhaps, or a carousel spinning in the night. To succeed here you'll need to see past the obvious and look for the hidden images create by the motion over time.

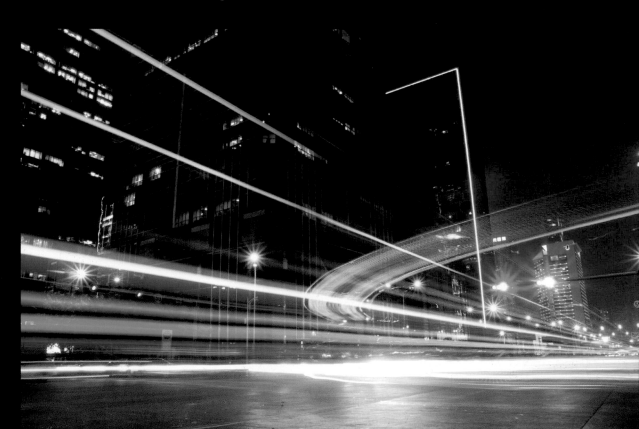

→ **More than movement**
Motion blur can also play a narrative role in your photography, as with this shot in which the slight blurring of each person in this shopping mall speaks to the fast-paced humdrum of commercialism.

Challenge Checklist

→ Get your tripod out of the closet for this challenge because you're going to need it. A steady tripod is your best friend when it comes to interpreting motion.

→ Often on bright sunny days the light is too intense to set a long shutter speed without some help, so be sure to bring along your neutral density filters. These filters allow you to reduce the light entering the lens without altering its color or quality in any way.

→ Look beyond the obvious subjects when it comes to recording motion: Leaves blowing in the wind can create beautiful patterns of color and light, as can the taillights of cars at night as seen from an overpass.

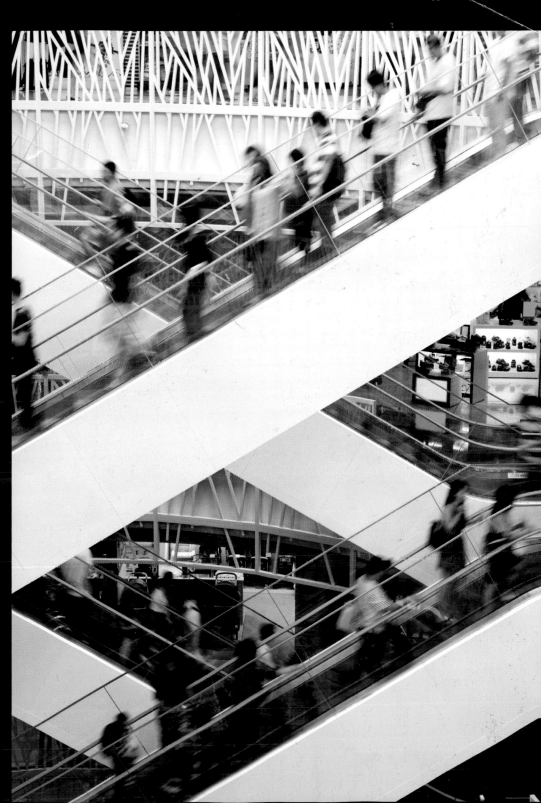

Review

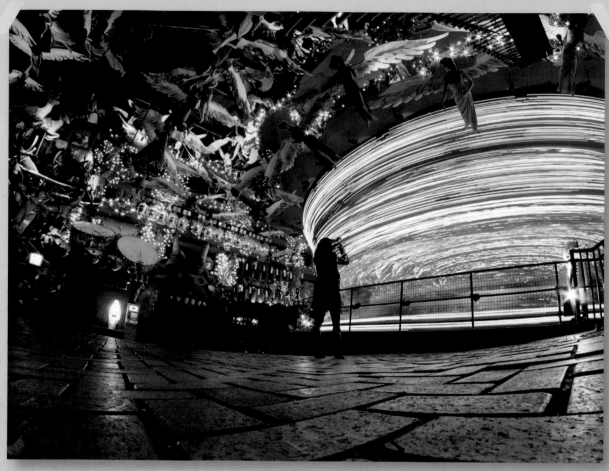

© Natahn Biehl

A 3-second exposure captured the rotation of the carousel's lights while the camera was carefully balanced on the floor. f4 at ISO 200.
Nathan Biehl

Good improvisation for the camera position, and that's a very short focal length for the fisheye to keep most of the close tiles in focus. I like the contrast that a 3-second shutter speed gives between the carousel and everything else.
Michael Freeman

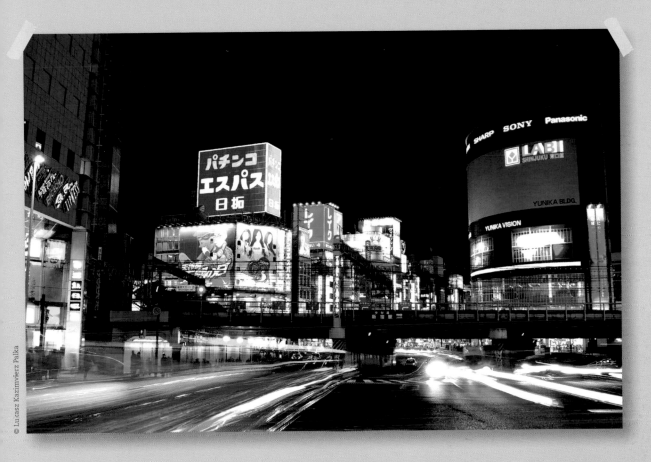

© Lukasz Kazimierz Palka

I set the camera to f11, ISO 200, and +1.3 EV in order to give bright light sources a glowing effect and properly expose the shadows. This also forced the camera to choose a slow shutter speed (2.5 seconds) which stretched out the tail lights of passing cars in a manner which calls to mind the motorcycle chase in the film *Akira*.
Lukasz Kazimierz Palka

You don't say what exposure mode you were using, but I'm assuming aperture priority. The exposure is full enough to make the bright Japanese city lights dominant. All good, although it's a pity that the oncoming traffic flow isn't as busy. Personally I might have re-framed to the left a little.
Michael Freeman

Exposure Modes

All but the simplest digital cameras have enough exposure modes (and specialty exposure modes known as scene modes) to make your eyes spin. But once you have a good understanding of what each of the exposure controls does, it's much easier to sift through the various exposure modes on your camera and choose the one that is best for a particular situation. Each of the primary exposure modes is design to solve a particular problem and, while you will eventually find yourself just relying on one or two for most of your picture-taking needs, it's a good idea to experiment with each of them early on and get to know their advantages. Here briefly are each of the modes and some of the reasons that you might use them:

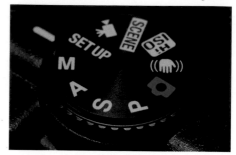

↑ **Exposure Mode Dial**
Most digital cameras have an exposure-mode dial like this one, though some simpler cameras list modes as menu options. In both cases the icons are typically the same and enable you to quickly match your camera's exposure response to your subject.

Automatic

Also known as the "green mode" (because it's typically colored green on the exposure-mode dial) this is the all-encompassing fully automatic mode. The camera typically sets its own ISO (based on its interpretation of the ambient lighting situation) and also sets the shutter speed and aperture. This is fondly referred to as the "beginner" mode in some circles for obvious reasons: You don't need to know a thing to use it other than how to turn on the camera and press the shutter button. The flash will also typically turn itself on when the camera senses that the lighting level has dropped below what it deems acceptable. The nice part of this mode is that you can just concentrate on the viewfinder and ignore all technical decisions. But the obvious downside is that you've surrendered all creative control. For example, you have no control whatsoever over depth of field or subject motion. Usually white balance is often chosen for you, as well. The one override that you may have available to you even in this mode is exposure compensation (see page 97).

Program Automatic

The flexibility of this mode varies from one camera model to the next, but typically the camera still sets both aperture and shutter speed for you. The difference is that you can (often must) set the ISO yourself, so that you are matching the sensor's light-sensitivity to the existing light. The primary advantage in this mode is that, with most cameras, there is a command dial that lets you scroll through the various equivalent aperture and shutter speed combinations. If, for example, the camera sets an exposure of 1/125 second at f8 and you know that you want more depth of field, you can scroll through the aperture settings to find a smaller aperture. You can also set the white balance manually when using this mode, and make exposure compensation adjustments as you see fit. Another subtle difference is that the flash won't pop up automatically and you will probably have to flip it on manually.

Shutter Priority

This is the mode to choose when making creative decisions regarding subject motion is your primary concern, because here you select the shutter speed and the camera chooses the correct corresponding aperture setting. This is the mode favored by sports and action photographers because it enables them full control over how the camera is responding to and capturing subject motion—if the action is fast and needs to be frozen, a fast shutter speed is set; if the intent is to blur the subject as it is moving, longer shutter speeds can be explored until the optimum amount of blur is reached.

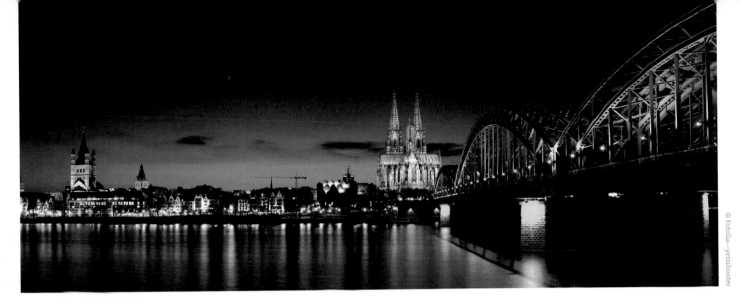

↑ All modes lead to Rome

Or, in this case, all modes may lead to a great night shot of the Rhine near Köln, Germany. Any of the main exposure modes could capture this shot, but you have to decide which works best for your vision.

One caution to keep in mind here is that as you select the shutter speed, you must keep an eye on the shifting depth of field (if that is a concern). If, for example, you select a very fast shutter speed of 1/2000 of a second, the camera will likely be forced to select a very wide aperture setting, and this means almost no depth of field. Conversely, if you select a very slow shutter speed—to blur the gate of a racehorse or the flow of a mountain stream, for instance—the camera will select a relatively small aperture which will potentially create a situation where too much of the scene is brought into focus. Check sharpness with your depth-of-field preview button regularly.

Aperture Priority

Often your primary concern in choosing exposure settings is controlling depth of field. In those situations the Aperture Priority mode is ideal because it lets you select the aperture setting while the camera selects the appropriate shutter speed. If you know, for instance, that you want to restrict depth of field in a head-and-shoulders portrait, you can select a very wide aperture and the camera will match it with the right shutter speed for a good exposure. Or, if you happen to be shooting a wide-open landscape and want to have sharpness from near to far, then select a small aperture and, again, the camera will choose the right shutter speed setting.

One thing to keep in mind when using this mode is that if subject motion is an issue, you must keep track of the shutter speed that the camera is selecting. You may have to raise the ISO, for example, if by selecting a small aperture the camera is setting too slow a shutter speed and your subject is creating more blur or motion that you desire. Also, keeping the camera on a tripod when using small apertures will negate any chances of camera shake during long exposures.

Manual Mode

The Manual exposure mode provides the most control, but the least assistance from the camera. In this exposure mode you are responsible for setting both the aperture and the shutter speed. To use this mode you can use the camera's light meter (or a handheld meter) as a guide in selecting the exposure, but you are completely free to accept or ignore its recommendations as you see fit.

The Manual mode is very useful when you are fairly certain that the camera's meter is going to be misled by a complex or contrasty subject and you want to use your experience to override its settings. In photographing a scene that exceeds the sensor's known dynamic range (typically around 10 stops for a mid-range camera), for example, the meter will provide an "average" reading of the scene. But in this case you may have to make a decision to abandon some shadow information to preserve highlights. Also, in all cases when you're using a handheld meter you will have to use the manual mode because otherwise the meter will ignore your settings and set exposure based on its own readings. There are also many extreme exposure situations—making extremely long exposures to capture star trails, for example—when the only way to set such exposure times is to use the Manual mode.

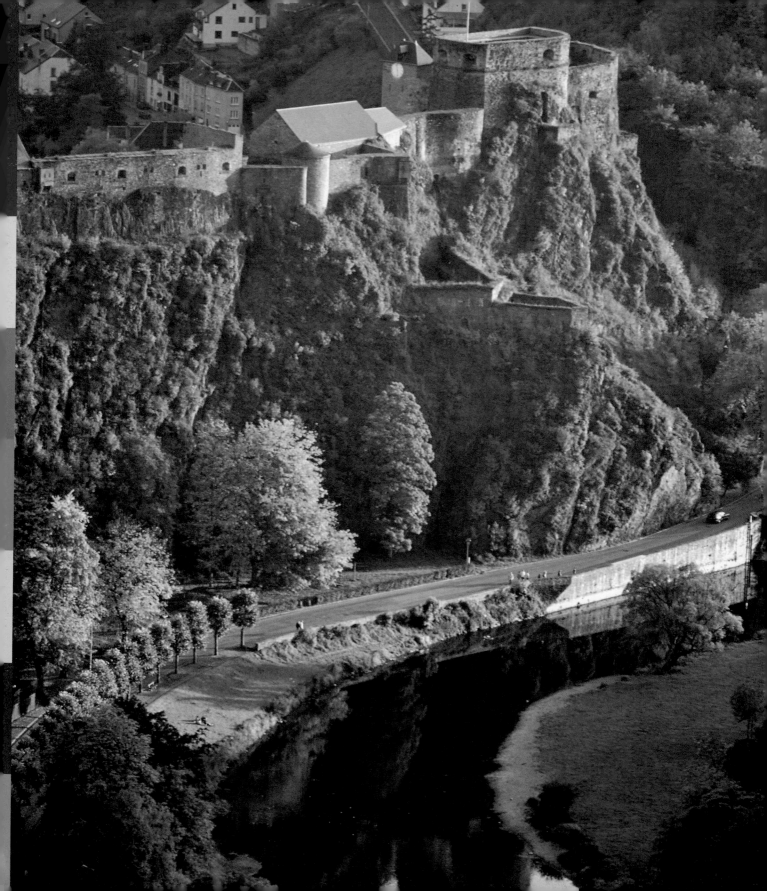

Metering the Light

Before you can begin to capture exposures in any significantly creative way, there is one fundamental bit of knowledge that you must possess about any given scene: How much light is actually falling on that scene? More precisely, perhaps, you have to know how much light is reflecting off the scene and back to your camera's sensor. Like a baker preparing their ingredients for a recipe, accurate measurement is everything. Even if you decide later to toss away a dash of this (a dark shadow perhaps) and a pinch of that (intentionally letting a highlight blow out), you must begin at the beginning and that means taking an truthful assessment of the primary ingredient at hand—namely, light.

When it comes to measuring the illumination in a scene, in fact, your digital camera is a not-so-minor technological miracle. At the mere tap of the shutter-release button the camera instantly analyzes not only how much light is coming from your subject, but how far away that subject is, how much contrast is contained in the scene and, in many cases, it has also made a pretty darn good guess about just what that subject happens to be. It's downright amazing.

Even more impressive, in order to help you interpret the way that light is reflecting from a particular subject in a useful way, your camera's meter contains several unique metering modes: one for measuring complex lighting conditions of the entire composition, one for isolating just a portion of the scene for more detailed measurements, and yet another for taking readings from fingernail-sized bits of a broad scene. Your job in all of this, of course, is to guide your camera's meter in selecting the important parts of a scene to measure and in interpreting those readings wisely. But not to worry, your camera's meter will guide you every step of the way.

Histograms & Meters

In order for you to get the best results from your camera's light meter, of course, it's important that you understand exactly how it performs it's primary chore—and that you understand both its areas of expertise and its short comings. Knowing how your meter measures light and what

its limitations are will help you to manipulate and interpret its results and when it's time to intervene. And knowing what your sensor's limitations are in dealing with the existing light is vitally important. Knowing, for instance, that your camera's imaging sensor has a vastly more limited dynamic range (range of contrast) than your eyes and brain do is supremely important in interpreting the information provided by your meter.

Reading the Histogram

Perhaps the most valuable tool available to you as a digital photographer is the luminance histogram. This chart horizontally maps the tonal values of a scene from pure black at the far left to pure white at the far right—on a scale of 0 to 255. The vertical axis shows the number of pixels in each particular tone. As you know from our discussion on dynamic range, your camera sensor is limited in its ability to capture only a certain range of tonal values. These stops can be very bright (mostly highlights) or

very dark (mostly shadows), but what they can't be is very far apart. If your camera has live view, you can observe the histogram as it calculates the exposure of your scene in real-time on either the LCD or electronic viewfinder. But even if your digital camera doesn't offer this feature, you can almost always activate the histogram as you review an already captured shot in playback. Time permitting, you can then observe if your tonal values are optimally distributed, adjust your exposure settings, and reshoot as necessary.

So what is the optimal histogram? The most important goal is to prevent your histogram from bunching up too much at the far ends, which indicates that detail is being lost in pure white or pure black. Ideally, your histogram should start at the bottom left corner, rise into a mountain, peaking in the middle of the chart (the mid-tones), and gracefully taper off back down to the bottom right corner.

Of course, not all scenes will give you the opportunity to create an optimal histogram, regardless of how delicately you expose the shot—but the histogram will still be an essential tool in helping you combat such high-dynamic-range, high-contrast conditions. We will cover these particular methods in greater detail in the following chapter, but for the time being, the important thing is to understand how your histogram works, and how it reflects the way your camera sensor measures light, and captures and records that light as image data.

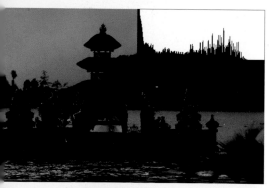

↖← Finding the middle ground

The top image is overexposed, with hardly any detail in the sky and background. This is visible in the large amount of pixels bunched up against the far-right side of the histogram. Likewise, the middle image is underexposed, with most of its pixels slammed up against the far left. The bottom image is properly exposed— in the sense that all of the pixels taper off before overexposing the highlights, and the few pixels cut off in the blacks are not too much of a worry. The majority of the data is safely captured between the extremes of the chart.

TTL Meters

All in-camera light meters fall into one broad common category: TTL-type meters. Standing for Through-The-Lens, TTL metering means that the light is being measured (by a separate metering sensor) after it has passed through the lens and typically is measured at (or close to) the imaging sensor. This system creates an extraordinarily accurate means of light measurement because the light is being measured after it has passed through the lens and any lens filters that you might be using. What the meter sees in terms of illumination is exactly what the sensor will be recording.

Conversely, in pre-TTL cameras if you used a lens filter you had to take the amount of light that was absorbed by the filter into consideration when calculating your exposure. This compensation, known as the filter factor has been rendered virtually obsolete by TTL metering. While calculating the filter factor wasn't difficult, measuring the light after it passes through a lens filter is exceedingly more accurate.

Also, since the light is being measured internally, the meter does not have to make adjustments for other types of lens accessories like close-up extension tubes or telephoto extenders. Even the light from your electronic flash is measured—and the flash output controlled—after the light has bounced off of your subject and passed through the lens.

The real beauty of the TTL system, then, is that no matter what lens or filter accessory you employ, the metering sensor doesn't have to compensate (or have to assist it) in any way. For both you and the camera the process becomes one of speed, elegance, and simplicity.

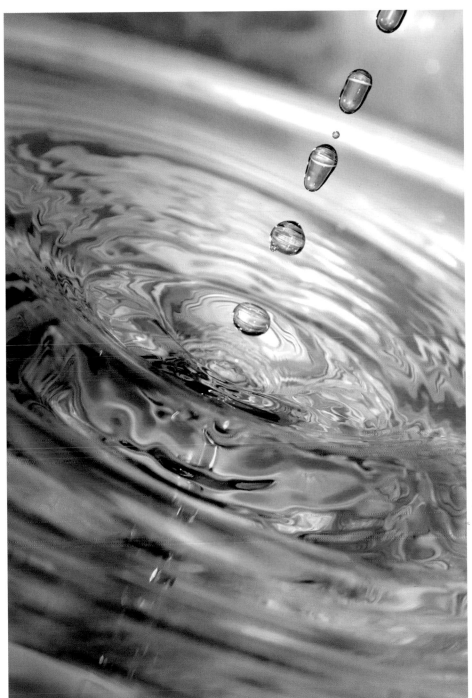

© Marcin Chodorowski

↑ **Flash made simple**
The high-speed flash necessary for capturing these water droplets requires delicate calculations—that fortunately occur in an instant thanks to automated TTL metering.

How Light Meters See the World

In preparing to meter any scene, it's important to acknowledge a very significant difference between the way that you see the world and the way that your meter sees it. While you're happily experiencing and photographing the world in all of its splendid Technicolor glory, what your meter is actually seeing—and attempting to record—is a visual story told in a palette of grays. Or more accurately, a world of one gray: a tone referred to in photography as 18-percent gray, or more commonly, middle gray.

Indeed, whether they are built into your camera or handheld (and we'll talk about handheld meters later in this chapter), all meters are programmed to see and record the world around them as that single shade of middle gray. And in the world of photographic tonal values, that gray lies precisely halfway between absolute black and pure white. (And incidentally, the reason that it is 18-percent gray and not 50-percent gray is because the math is based on an algorithmic scale, not a linear one.) While this may seem like a rather

limited point of view it is, in fact, the basis for all exposure measurement—and it's a system that works with impressive precision and reliability. When you aim your camera at a red apple, for example, the meter sees a gray apple. When you meter from the blue sky, the meter sees a gray sky. And if you're photographing summer

↑ **Metering sensors are colorblind**
Learning to see each color, and indeed batches of different colors, as shades of gray will help you understand and better use your camera.

landscape of yellows, greens, blues and reds what your meter wants to do is average all of those different tonalities into one big canvas of middle gray.

→ **Measuring brightness**
This diagram shows how brightness measurements relate to f-stops, with middle gray at the center, and deviations into light and dark indicated by + or - f-stops, respectively.

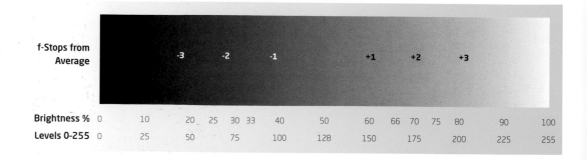

f-Stops from Average		-3	-2	-1		+1	+2	+3			
Brightness %	0	10	20 25 30 33	40	50	60 66 70 75	80	90	100		
Levels 0–255	0	25	50	75	100	128	150	175	200	225	255

The reason that this system works so well is that whatever you aim your meter at, will be recorded as middle gray. If you are careful to meter a subject that happens to be middle gray then that subject will be exposed perfectly and all of the other tones will naturally fall into their proper place. Those tones that are lighter than middle gray will record lighter and those that are darker will record darker. A perfect system.

In the section on the zone system (see pages 112–115) we'll talk about how you can transpose any metered tone to any other tone that you like, but for now the important thing to remember is this: whatever you meter will be recorded as a middle gray and so if you meter a subject that is middle-toned, the entire scene will be correctly recorded. Again, this is not to say, however, that all of the tones can be recorded because some may lay outside of your sensor's ability to record them.

The key to setting a perfect exposure then is to find a subject that provides that ideal middle-toned value to meter.

→ A still-life scene

Daylight coming through a window, falling on a variety of colors each with differently reflective surfaces, with shadows bunched up at the top of the frame. In such a diverse scene, you can either directly tell your camera which tone to treat as middle gray, or have your camera average all those tones together in order to calculate an even exposure for both the shadows and the highlights.

In Search of Middle Gray

While it may seem an elusive task to find a reliable middle tone in any scene, it's actually much simpler than you might imagine. Most outdoor scenes, both natural and man-made, contain a number of nearly perfect middle tones for metering, including:

Clear Blue Sky

A dark blue sky on a sunny day is makes setting exposure for landscapes very easy. Blue skies are particularly useful when the scene itself contains large areas of light or dark that might otherwise fool the meter. Metering the sky is also useful when you are photographing a landscape in very contrasty lighting, or when the scene is backlit by strong sunlight. But it does need to be a clear day with a distinctly rich, blue sky, clear of any haze or cloud cover that could skew your reading.

Light Green Foliage

Whenever you're photographing a scene that has a lot of green grass or light-green foliage, you can set a very accurate exposure by metering those green areas. Again, this can be particularly useful if you're photographing a landscape that contains tones that might fool your meter. If you're photographing a dark, rocky outcropping with green trees, just meter from the foliage and the rest of the tones will fall into place. If you find your scenes metered this way are coming out too light, use your exposure compensation feature (see page 97) to reduce the exposure by about 2/3 of a stop.

↓ **Abundant green for an easy scene**
One nice thing about photographing nature subjects is that you're often presented with plenty of green reflective surfaces off of which to meter an accurate, reliable middle gray.

© Steheap

↑ **Catch the light**
Regardless of which metering target you use to set your exposure, it is always important to make sure the area off of which you are metering is reflecting the prevailing light.

Gray or Red-Brick Buildings

Old, unpainted barns are ideal, naturally gray metering targets, as are the boards of an old wooden farm cart or a pile of weathered lumber. An old school house or the side of a red-brick store are likewise excellent—the key is to make sure they are reflecting the prevailing lighting conditions and not cast in shadow.

Dark Caucasian Skin

Different skin tones in fact appear remarkably similar to a metering system. Darker skin can often be metered directly, which can make portraits quite easy. Lighter caucasian skin tones typically need to have 1 to 1.5 stops added to the exposure in order to render a middle gray tone. Once you know the neutral gray value of your own skin, you can use it as a mobile metering subject that you'll always have with you.

Gray Card

One reliable method, if your shooting allows you to spend a little time preparing, is to carry with you a mid-toned gray card. These are available from good camera retailers, and are made so that they reflect exactly a mid-gray to the camera. It reflects 18% of the light reaching it, and the reason for this number is the non-linear response of the human eye.

↓ Expose, then compose

For this scene, the camera was pointed down so the green grass occupied the full frame, then keeping the shutter release half-way down—the scene was recomposed and shot.

Lock Selective Readings

In order to use any of these naturally occurring middle tones, of course, you will have to isolate them from the rest of the scene, either by using a selective-area metering mode (see the next section), zooming in to fill the frame with just that subject, or simply by moving closer to it. Whenever you meter selectively, however, it's important that you lock that reading in before you recompose and shoot the final scene. If you don't, then the meter will simply override all of your hard work and set the reading it would have originally chosen. Virtually all digital cameras allow you to lock a meter reading by keeping the shutter button half-pressed. As long as you continue to keep your finger on the trigger, the meter reading will remain fixed.

Because this feature typically also locks focus, however, it is only useful if the subject that you are metering and the one you are shooting are the same distance from the lens. That rarely being the case, you may have to switch your camera to the Manual Exposure mode (see page 59) and set the exposure directly. Some cameras have a separate exposure-lock feature that allows you to meter independent of the focusing system (see your manual to see if yours does).

Metering Modes

All digital cameras contain reflected-light, TTL-type meters that utilize at least one of three different types of metering "modes" in order to calculate exposure off of either the entire scene, or some specific part of it. Compact cameras typically offer only one metering mode, while more advanced cameras (advanced zooms or DSLR cameras) may offer all three. The difference in how each mode operates is based largely on how much of the scene the meter is viewing. Switching from one metering mode to another is very simple—normally just the press of a button or the turn of a dial. It's well worth trying out each mode so that when the need arises, you're comfortable with how to access it and how to use it.

Matrix Metering

Also known as multi-segment or evaluative metering (depending on your particular camera manufacturer), in this mode the camera looks at the entire scene and considers the lighting as it reflects from numerous specific areas throughout the frame. This is the default mode used in almost all digital cameras, from basic compact cameras to the most sophisticated DSLR models. It is far and away the most complex and sophisticated form of light metering and is exceedingly accurate in even the most complex situations.

In this mode the meter divides the frame into set pattern or grid of areas that can range from a very basic half dozen or so segments to more than a thousand on some high-end DSLR cameras. Once you activate the meter by partially depressing the shutter release, the camera analyzes the amount of light coming from each of those segments and then compares the pattern of illumination to a library of subjects that have been stored in the camera's onboard computer. On some cameras the meter may be comparing the scene to as many as 30,000 exposures that are stored in the camera's memory. In programming the data bank for these meters, the manufacturers include a vast array of both common and complex scene examples—landscapes, portraits, close-ups, etc.

↓ **Even exposure**
Had only the sand been metered, the camera would likely have underexposed this beach scene. However, including the sky, sea, and particularly the green grass elements helped the onboard computer recognize the scene for what it was and properly expose for it.

© Joe Gough

By making this comparative analysis of the scene, the camera is able to make a fairly educated guess about exactly what the subject is that you're photographing—and which parts are likely to be most important. If the camera sees a tall, relatively dim vertical area that is surrounded by a bright field of illumination, for example, it may conclude that what you're photographing is another person standing on a bright sandy beach (or a snowy field). It then calculates an exposure that will moderate the brighter areas while providing adequate exposure for the face. It's quite an amazing exercise in high-intellect technology and it works stunningly well (when properly used).

In creating its exposure, the matrix meter will take many related bits of information into account (in addition to brightness levels), including the distance to the subject (based on focusing information provided the by the lens—though this also varies from manufacturer to manufacturer), the direction and intensity of the light, the contrast, RGB values for each segment, and the color of the subject. The camera then goes through a complex routine based on a series of advanced algorithms to set the exposure—and it does all of this in fractions of a second.

→ Recognize when Matrix is appropriate

Never forget that your camera is still just a computer. It is up to you to use Matrix metering appropriately, and know which scenes for which it is best suited. For instance, this landscape shot, with blue sky, green mid- and foreground elements, and plenty of sunlight is perfectly suited for Matrix metering. Ultimately, the key to using Matrix metering is to become so familiar with the way it works in your particular camera that you can anticipate the lighting situations where it might have difficulty, or need compensation input from you.

© Fotolia—EF-EL

Make the Most of Matrix Metering

Challenge

↓ Suitable subjects
Most matrix metering systems render artificially lit night scenes quite well, and if it's close enough to dawn or dusk, you'll be able to capture some rich blues in the sky above.

Odds are that you have already performed this challenge many times because this is the metering mode that most of us use from day one. And with good cause—the matrix meter in your camera will do a great job metering even the most complex of lighting situations. And that's exactly the nature of this challenge: Rather than testing your matrix metering on an average subject, see how it does on a more extreme one.

The next time that you notice that a brilliantly sunny day is creating a startling amount of contrast, put your matrix meter to the test. But before you head out to shoot, take a few minutes to review the metering details in your camera manual and find out just how many segments your meter is reading when it looks at a scene, and then see if you can find roughly how many past exposures the manufacturer has programmed into your camera.

→ Filling the frame

Matrix metering is often a good choice when your subject is completely filling the frame from edge-to-edge, with uniform lighting across the full scene.

Challenge Checklist

→ Shoot JPEG for this challenge so that you can see just how well your meter does straight out of the camera.

→ Look for scenes that have a wide range of both dark and bright subject area and a wide variety of colors.

→ Don't be too concerned about what the subject is for this challenge. What you want to see is just how well your meter handles complex lighting situations. You might also try it in naturally high-key or low-key settings to see if the meter is fooled by its limited dynamic range.

Review

© Nathan Biehl

This was a drive-by shot from the highway. I set the camera to f5.6 in Aperture Priority mode to allow for a fast shutter speed as the camera calculated the exposure. 1/1600 second at ISO 200.
Nathan Biehl

Interesting to compare the results of 1/600 second on the flying pigeons on page 50 with the lateral motion of the car here on the foreground grass. It's a worthwhile experiment, but to be honest if a static landscape like this is worth shooting, it's also probably worth stopping the vehicle for.
Michael Freeman

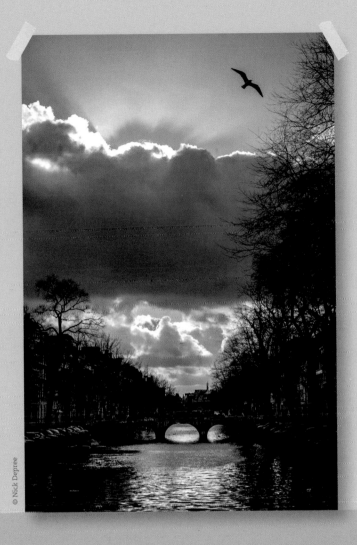

© Nick Depree

Keizersgracht, Amsterdam. With the sun out of sight behind a cloud, Matrix metering exposed the scene perfectly and I was able to concentrate on my framing, and timing the shot when the bird flew exactly where I wanted it. f5.6 at 1/1250 second, ISO 200.
Nick Depree

Matrix metering does its job well and as it should. You need to have confidence that it will work as you expect, which is why with a new camera I always try it out in different lighting situations to see if it has any idiosyncracies. You were rightly confident here.
Michael Freeman

Selective Metering Modes

Center-Weighted Metering

One of the downfalls of matrix metering (and to be honest, the downfalls are mild and relatively rare) is that the meter is always considering the entire frame. In most situations this is not only acceptable but quite useful since it takes all parts of a scene into consideration. There are situations, however, when the most important subject—the one that you want metered accurately—takes up only a small portion of the frame, and this is where center-weighted metering can be very useful.

Though it still considers the illumination information from the entire frame, the center-weighted metering mode biases or "overloads" its readings to a small central portion of the frame. The center-weighted area is indicated by a circle in the viewfinder and typically the meter concentrates from 60 to 80 percent of its readings from that central area. If, for example, the frame is divided into a 70/30 split where 70-percent of the information that is being considered is within that central circle, then the rest is based on the other 30-percent of the frame.

Center-weighted metering is ideal for situations where a relatively small, important subject is surrounded by a excessively bright or dark background. If you are taking an informal portrait of a cross-country skier against field of bright white snow, for instance, you can use this mode to meter directly from the skier and thereby reduce the meter's consideration of the surroundings. Similarly, if you are photographing a strongly backlit flower surrounded by bright foliage, you can read directly from the blossom and get a much more accurate exposure for the flower.

© Fotolia—Gorilla

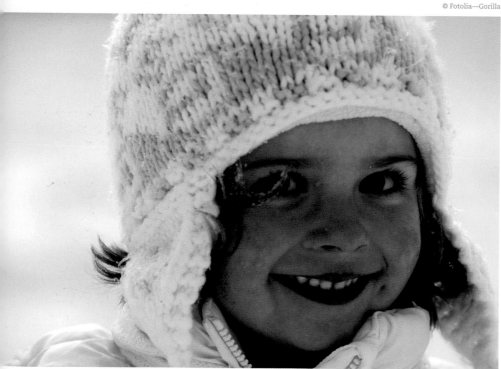

© Sylwia Schreck

↑ **Don't worry about the edges**
Center-weighted metering mode allowed the edges of the frame to be pushed into the highlights, in order to capture the full tones of the inner folds of these rose petals.

← **Skin versus snow**
While it doesn't completely ignore the edges of the frame, center-weighted metering mode recognizes that whatever is in the center (in this case, the portrait subject) is what's important.

Spot Metering Mode

Spot metering takes the idea of center-weighted metering to the ultimate extreme and reads an even smaller area of the frame—usually an area that is between one and five percent of the viewfinder area. On most cameras this area is indicated at the center of the frame, but on some DSLR cameras it is a floating area and you can change its placement.

One significant difference between center-weighted and spot metering, however, is that in the spot-metering mode the camera is not taking any other portion of the viewfinder into consideration. Rather, the meter reads exclusively from the indicated spot area. Spot metering is particularly useful when the important subject takes up a very small part of the frame—but when you meter off such a small area, it's important that you've carefully chosen the optimal area to read. Remember that the reading is telling you what settings will reproduce that small area as a mid-tone.

One other benefit of spot metering is that you can use this mode to compare several (or many) very specific tonalities within a scene. This enables you to measure the true dynamic range of a scene by measuring both its brightest areas and its darkest. You can also use a spot reading to place a very small and specific subject at middle gray (and this is the basis of metering using the Zone System—see pages 112–115).

Again, with both center-weighted and spot metering modes, it's critical that you use your camera's exposure-lock function to hold that reading if you recompose the scene after metering.

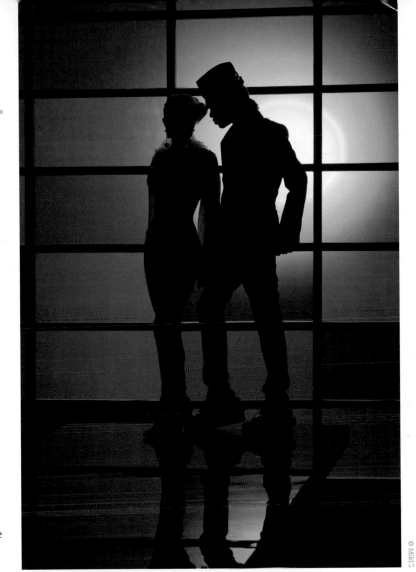

© MIKI

© Garret Bautista

↑ **Spot-metered silhouettes**
Silhouettes (see page 150) are a situation in which you don't want to meter off your subject at all. Here, the colored background was spot-metered, leaving the two figures completely underexposed.

← **Spotlit subjects**
Spot metering is excellent for dramatically capturing spotlit subject, ensuring only the brightest area is properly exposed and letting the rest of the frame fall off into shadow.

Challenge

Limit Yourself to Spot Metering

↓ Mont Saint-Michel
Many monuments and iconic buildings are lit in such a way that spot-metering off their surfaces creates an exposure that accentuates their specific structure while the rest of the frame is left more subdued.

Handle this challenge well and you'll have given yourself a bit of knowledge and experience that will see you through some very tricky metering situations. As you know by now, your camera's spot meter is designed to read a very finite area of the frame—often an area that's only a few degrees in angle of view. But isolating those few degrees can be the only way to precisely meter the important areas of a complex scene.

By combining your ability to read such a small area with your knowledge that your meter wants to render that area as a neutral gray (Zone V if you're following the Zone System), you'll know exactly how to set exposure for the most important part of the scene. Whether the surroundings are overly bright, very dark or even intensely dappled with both, by metering just the key subject area you have taken control over setting the best possible exposure.

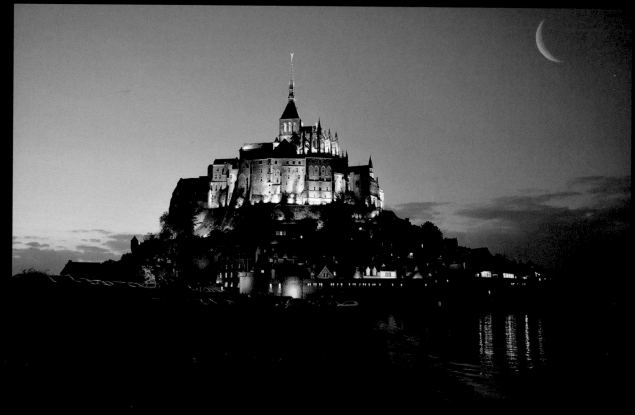

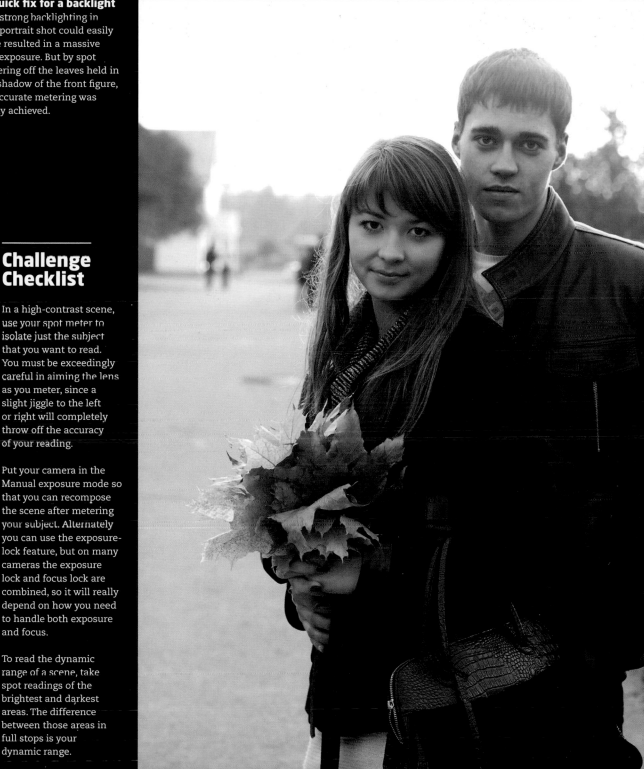

The strong backlighting in this portrait shot could easily have resulted in a massive overexposure. But by spot metering off the leaves held in the shadow of the front figure, an accurate metering was easily achieved.

Challenge Checklist

→ In a high-contrast scene, use your spot meter to isolate just the subject that you want to read. You must be exceedingly careful in aiming the lens as you meter, since a slight jiggle to the left or right will completely throw off the accuracy of your reading.

→ Put your camera in the Manual exposure mode so that you can recompose the scene after metering your subject. Alternately you can use the exposure-lock feature, but on many cameras the exposure lock and focus lock are combined, so it will really depend on how you need to handle both exposure and focus.

→ To read the dynamic range of a scene, take spot readings of the brightest and darkest areas. The difference between those areas in full stops is your dynamic range.

Review

© Nick Depree

Church of Our Lady (Onze-Lieve-Vrouwekerk), Bruges. With a very dim foreground and very bright background, I spot-metered on the statue's face as my chosen point of interest, and let the backlight bloom around her.
f5 at 1/50 second, ISO 1600.
Nick Depree

...And the result is very interesting! This is a good and slightly unusual use of spot metering in a high-dynamic-range situation, and it works beautifully. The head, glowing and overblown around the edges, looks ethereal. Not the exposure that many people would have chosen, and all the more impressive for it.
Michael Freeman

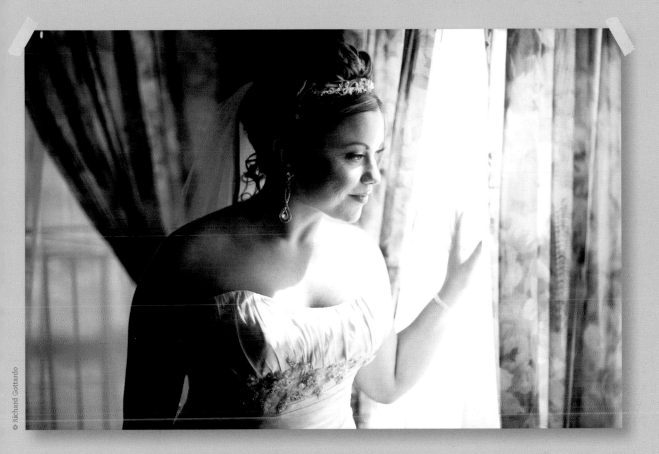

© Richard Gottardo

This shot would be very difficult to get without using spot metering. The bright, harsh light coming from the window would cause the camera to underexpose the rest of the shot to compensate. Spot metering was used in order to maintain proper exposure on the brides face while blowing out the light coming from the window.
Richard Gottardo

Yes, an excellent case of your identifying the key tones on the face and making sure that they reproduced normally. The blown-out window highlights simply add a glowing effect to the shot, as in the other picture opposite.
Michael Freeman

Handheld Meters

As sophisticated and reliable as built-in meters are, there are still photographers that rely on separate handheld meters. Photographers choose handheld meters for a variety of reasons. Some photographers, of course, are using studio and field cameras that don't have light-metering capability, while others may be using film cameras that pre-date built-in light meters. There are also, naturally, photographers who simply have more confidence in using a meter that can be physically placed anywhere in the scene to take a close-up reading of a particular subject area.

One of the advantages of a handheld meter, in fact, is that you can walk right up to the subject and meter either the light reflecting from it (which is how a camera's TTL meter works) or landing upon it. The great advantage of this latter method, known as an incident reading, is that you don't have to bother about whether the subject is inherently bright (like snow), or naturally dark (a black cat). The same light falls on everything, and in principle, this reading should work for everything. In metering this way, you are making a conscious decision to eliminate the camera optics (and any lens accessories such as filters or close-up extension tubes) from the process. In so doing, however, you must always remember to factor in the light lost to such accessories—and this, in turn, adds extra steps to the metering process.

One other worthy benefit of using a handheld meter is that often they offer the ability to record and compare or

average several different readings. If you're photographing a landscape with both extremely bright and dark areas, for example, you can take a reading from each area and determine the dynamic range of that scene. If, for instance, you get a reading of 1/60 second at f2.8 in the deep shadow areas and a reading of 1/60 at f16 in the bright areas, you know that there is a five-stop range between the two. By knowing the dynamic range of your camera, you can

↑ Studio setups
Studios often offer the controlled lighting conditions and sufficient time for you to carefully meter off of exactly the area you want properly exposed.

assess whether or not your sensor can capture that range (and in this example, almost all DSLR cameras would be able to record that range).

Types of Handheld Meters

There are essentially three types of handheld meters, though often they are combined into a single meter or can be configured into a single meter using modular accessories.

Reflected-Light Meters

Reflected-light meters operate very similarly to built-in meters in that they measure the light after it has bounced off of a given subject. The advantage of this type of meter is that you can meter

→ Bouillon Castle
The abundance of green vegetation in this scene makes it an appropriate subject for a reflected-light reading—though it is important to measure off the brighter, sunlit area rather than the shadows at the bottom of the frame.

↓ Point-and-meter
Many meters offer a viewfinder attachment, allowing the meter to be used much like the built-in meter in your camera.

from the shooting position or you can move closer to take readings directly from specific areas of a scene. The disadvantage is that, unless you are using a spot-metering accessory or do move physically close to your subject, you are reading a much broader view

than you would if you were reading directly through the taking lens of your camera. Typically, reflected-light handheld meters take in a view of about 30-degrees, but this angle can be refined to a narrower field of view with accessories.

Handheld Meters

Incident Meters

Incident-light meters are different than most other types of meters because rather than reading the light that bounces back from a scene, they are measuring the light as it falls onto it. The advantage of this type of meter is that it eliminates false readings caused by the reflectivity of very bright subjects (or the lack of reflectivity of dark ones). Such readings can often mislead reflected-light meters.

Also, because they are designed to provide an exposure for middle gray, you can be assured that the reading you get from an incident meter will provide an exposure setting for a true middle tone—regardless of what the subject is. Incident metering, however, requires that you know where on the tonality scale (see Zone System, page 112) the important areas of your scene will land. If you are taking an incident reading of a white rose, for example, and you meter the light falling on the rose and use that exposure, you'll end up with a gray rose. You must know how much additional exposure is required to bring that rose back to it's natural white tonality and then set that reading on your camera. In the case of a white rose, by adding (roughly) two stops to the meter reading you will end up with a white rose.

Using an incident meter is also different in that you normally aim the meter back toward the camera when taking a reading (though in some cases you can aim it directly at the light source). If you are photographing

nearby or close-up subjects, this is easy because you can simply walk up to the subject, point the meter back toward the camera, and take your reading. If you're photographing broader scenes such as a landscape, you can still take incident readings by finding a representative area that shares the same light as your wider scene, and then meter within that area.

↑ **Accessories to match**
This light meter has been fitted with an incident dome—the white dome attached at the top. This can be replaced with a reflect-light attachment, or a viewfinder as seen on page 82.

← **Golden subjects**
Being made of highly reflective gold, this subject is a perfect example of when an incident-light reading will give you more reliable results, as it completely ignores the reflectivity of the subject itself and considers only the light as it falls on the scene.

Spot Meters

Available both as specialized handheld meters or as a modular offshoot of a handheld reflected-light meter, spot meters operate just as your in-camera spot-metering mode does. These meters allow you to focus in on a very tiny portion (often as small as one-percent) of the overall scene and then extrapolate the appropriate exposure for other areas of a scene. One of the nice aspects of using a spot meter is that on most meters you can take several readings from distinct small areas of a scene and save them to memory, either to review or to average electronically. And, as with broader types of reflected meters, you can use these readings to measure the dynamic range of a scene—very useful in extremely contrasty situations.

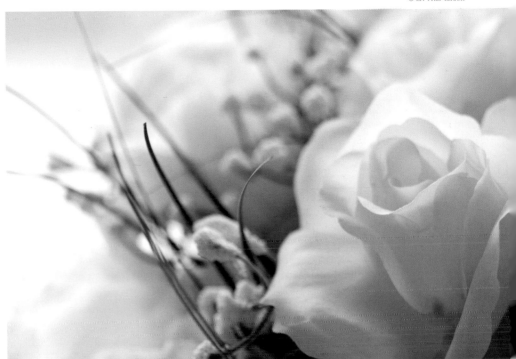

Flash Meters

Designed specifically for measure flash output and used most often in studio and location flash environments, these handheld meters measure flash illumination in either incident or reflective move. These meters provide the only accurate method of metering flash when TTL metering is not available.

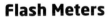 **Incident light on white**
White subjects can be tricky for incident-light meters, as their readings will assume the subject on which the measured light is falling will be middle gray—as you can see in the underexposed bottom image of this rose. The top image used the same light reading, but it was compensated for by adding two stops to the exposure.

Color Temperature

All light sources produce a unique color of light, and they are rated by their color temperature in degrees Kelvin (a system named after William Thomson, also known as Lord Kelvin (1824–1907)—though it's not likely that anyone will ever ask you). Color temperature numbers increase as the color of light goes from red to blue or from warm to cooler. Sunlight in the middle of the day, for instance, ranges from about 5000–5400K (depending on the latitude and exact hour) and is considerably more blue than tungsten lighting which is at about 3200K. Every light source that emits by burning (such as the sun or a tungsten filament) has a unique color temperature, though in most cases those temperatures vary to some degree—as lamps get older, or as the sun rises and sets, for example.

To the human eye, however, all ambient lighting—natural or artificial—seems acceptably white to us after a relatively short period of exposure to it. Whether you walk out into the golden light of morning or the bright much more blue light of noon, all light seems acceptably "white" to your brain. That is because the color receptors in your brain are constantly compensating and correcting for variations in the color temperature of light. And again, this happens so naturally and so quickly that we rarely take notice.

The same exact correction takes place when you walk from natural sunlight into an artificially lit room: The color of artificial incandescent lighting is much warmer in color than most daylight, for example, but once you're immersed in

that lighting, you barely notice it's warmth. We've all taken a walk in the blue light of twilight and noticed the reddish warmth of the artificial light spilling out from windows. Yet if you were to walk into any of those rooms, your eyes would immediately make an adjustment and in a matter of seconds you'd be seeing that light as a completely neutral color source. Your brain's ability to create a constant color of lighting helps you to walk through the world with a relatively constant sense of the neutrality of light (as false a reality as that may be).

→ **Balancing light sources**
As if dealing with the exposure for high-contrast lighting conditions wasn't enough, in scenes such as this, where there is an even split between bright daylight and dark shadow, your white balance setting (as explained on the following pages) becomes extremely important. Here, the more significant daylit subject has been given bias, while the shadow area to the right has been forced to take on a slightly blue color cast.

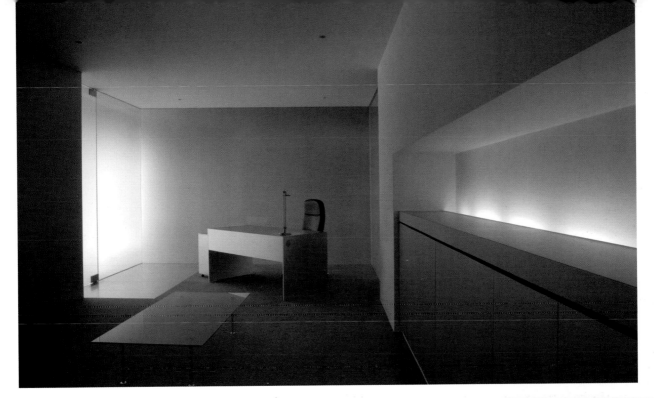

↑ White-balanced white

In this all-white room, it is exceptionally important to take an accurate reading of the ambient color temperature. Fortunately, the illumination, while artificial, is nevertheless consistent.

→ Daylight versus tungsten

In order for the outdoor scene in the window to have its blues and greens rendered faithfully, the interior of this room had to take on a much warmer color cast—particularly near the light source at the upper right of the frame.

The practical scale of color temperature

For photography, the important light sources for which color temperature has to be calculated range from domestic tungsten to blue skylight. Precision is difficult, particularly with daylight, because weather and sky conditions vary so much. There are also differences of opinion on what constitutes pure white sunlight.

K	Natural source	Artificial source
10,000	Blue sky	
7500	Shade under blue sky	
7000	Shade under partly cloudy sky	
6500	Daylight, deep shade	
6000	Overcast sky	Electronic flash
5200	Average noon daylight	Flash bulb
5000		
4500	Afternoon sunlight	Fluorescent "daylight"
4000		Fluorescent "warm light"
3500	Early morning/evening sunlight	Photofloods (3400K)
3000	Sunset	Photolamps/studio tungsten (3200K)
2500		Domestic tungsten
1930	Candlelight	

White Balance Control

← Neons and fluorescents
Commercial spaces typically use an array of artificial light sources in order to create a dynamic aesthetic. While it may appeal to the naked eye, it can wreak havoc on your digital images. You will often have to experiment with a few different white balance settings, none of which can perfectly match all the different light sources; but perfection isn't always necessary, as the viewer often expects to see a artificially vivid colors in such spaces.

Your camera's sensor, however, records the color temperature exactly as it is, without the compensation that our brains supply. All camera sensors have a default color balance (typically set at around 5500K to match daylight) and anything that varies from that will record with a clear and obvious color cast. The shifts aren't necessarily "wrong" and often they reflect the colors of the world in a very real way. The deep blue of a twilight sky, for example, records more blue because it is, in fact, bluer. Unless you tell the camera to make a correction back to "white" light, it will record the light exactly as it exists.

In the film days, you had to buy a film that matched the color temperature of your primary light source. If you were using daylight as the main source, for example, you simply bought daylight-balanced film. If you were using tungsten, however, you bought tungsten-balanced film. And if you were using an off-beat light—like fluorescent lamps—you would have to filter the lens to match the film you were using.

Digital cameras, on the other hand, have a built-in white-balance control that lets you assign a color temperature so that you can either "correct" the ambient lighting or exaggerate its color. The white balance, in effect, enables

you to tell the camera exactly what type of lighting that you are using—daylight, tungsten, fluorescent, etc. Most DSLR camera even have a further refinement that lets you tweak the color temperature of a given source (setting 3150K instead of 3200K for tungsten, for instance).

The white balance control is a terrific tool when you want to eliminate the color cast of a particular light source. If you're shooting in a nightclub, for example, and the lights have a very red bias, you can simply adjust the white balance back toward either a slightly less-red coloration or a completely neutral look.

There are Three Means of Setting White Balance:

(1) Automatic white balance adjusts the color response of the camera continuously and automatically without any help from you. As you change from one light source to another, the camera responds instantly. Typically the auto response will operate in a range of (roughly) 3500–8000K, but see your camera manual for the specific range.

(2) Source-specific white balance presets let you dictate exactly how you want the camera to respond by telling it the type of existing light. These vary from camera to camera, but the most common presets are described on the following page.

(3) Manual or Custom WB mode is the most precise means of setting white balance, because in this mode you take a test shot under certain lighting conditions and then set that temperature manually. The specific steps for creating such settings varies by camera, but the general idea is constant: First you take a clean, white surface and photograph it in the same exact lighting conditions as your subject—taking care not to have any shadows in the shot, and making the white target fill up the full frame; then, you instruct your camera to use that shot as the custom WB setting. Then, for all subsequent shots, the camera will use precisely the white balance setting that rendered your target subject pure white. With some cameras, you can save multiple custom white balances, and rapidly switch between them as you move from one light source to the next.

© U.P.images

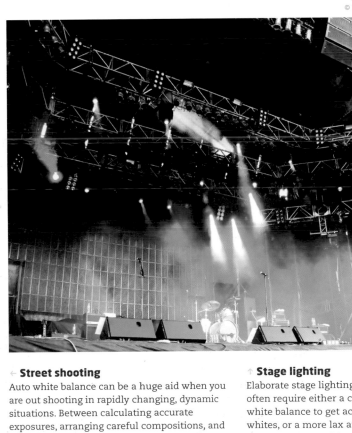

← Street shooting
Auto white balance can be a huge aid when you are out shooting in rapidly changing, dynamic situations. Between calculating accurate exposures, arranging careful compositions, and looking for decent subjects, you have plenty to worry about besides fixing color casts. Just make sure it's getting it in the ballpark.

↑ Stage lighting
Elaborate stage lighting setups often require either a custom white balance to get accurate whites, or a more lax attitude toward accurate whites in general, and using the color casts for creative effect.

White Balance Presets

Typical White Balance Presets Include:

Incandescent (3200K)
This is the mode to use for normal indoor household lighting and tungsten lamps.

Fluorescent (2700K–7200K)
Fluorescents are difficult to balance correctly because the lamps do not cover a continuous spectrum, and have distinct spikes in the blue and green parts of the spectrum. Because they are not incandescent, their light does not actually belong on the color temperature scale, but the preset does its best. Also, most fluorescents fluctuate widely from moment-to-moment, and also change radically as they age. Most cameras offer a fine-tune adjustment and the best way to balance these sources is often to take test shots and then use that adjustment to create a shift in the direction you need.

Direct sunlight (5200K–5500K)
This setting is intended for midday sunlight and generally works very well from mid-morning to mid-afternoon. Outside of this time frame you may notice increased blue or reddish color in the light.

Flash (5400K)
Flash lighting tends to run on the blue side, slightly bluer than midday sun, for example, and many photographers use this setting in daylight when they want a very neutral color balance.

Cloudy day (6000K)
Sometimes called Overcast, this setting helps to eliminate the excess blue light encountered on overcast days and in large areas of open shade by adding additional warmth. A good choice for outdoor portraits since the warmth tends to flatter most skin types.

Shade (8000K)
This setting is for working in shady areas on a sunny day, that are lit just by reflected light from the blue sky. It can be used to create a very warm look in landscapes, as well, though the look may be too intense for some photographers.

Remember that all white balance can be corrected in editing, and so it's not a particularly critical issue. In fact, if you shoot in the Raw file format, you can actually re-set the white balance of the original file during the conversion process with no loss of image quality. Even better, you can change your mind about the white balance each time you open and edit a Raw file, as the white balance is never set in stone on the original file.

Also, you can, of course, intentionally set a "wrong" color response that will exaggerate the coolness or warmth of a given light source—setting it to 4500K instead of 5500K to warm up the look of sunlight, for instance.

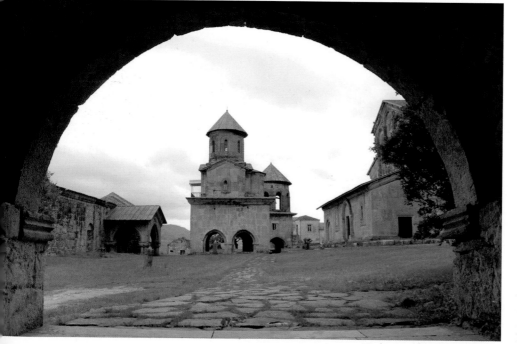

© Sala Jean

← Cloudy skies
While the Cloudy preset is useful on uniformly overcast days, very often the sky has a variable amount of cloud cover, and you will have to keep an eye on how the light is changing.

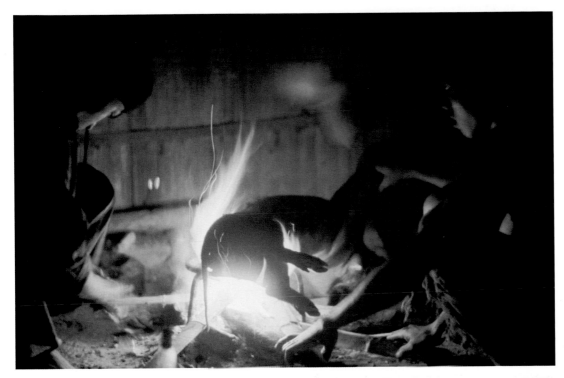

← Reds and oranges
While this fiery scene could have been captured faithfully and accurately, the result would have been too sterile and lifeless. The intensity of the scene and the heat of the subject is best represented with a strong incandescent color cast.

Manipulating Color Response

You can also use the preset choices to manipulate or exaggerate color response. By choosing "cloudy day," on a clear sunny day, for instance, you are adding warmth to the look of the scene because the camera will add warmth to correct for the bluish light of the cloudy day—even though you are working in a relatively neutral daylight. Many landscape and portrait photographers use "cloudy day" or "shade" settings as their default when working outdoors because they like the intensified warmth it provides.

Similarly, you can use a radically "wrong" white balance setting to intentionally mislead the viewer. By setting your camera to "tungsten" while shooting in daylight, for instance, you can create a sort of false twilight effect because the camera will add a substantial amount of blue to the image to correct for what it thinks is a tungsten light source. However, since the lighting is already somewhat blue you end up with exaggerate blue light—a technique used by Hollywood to create a "day-as-night" look.

© Terex

↑ Cold versus warm
Here you can see the interplay of two different light sources, with the neutral fluorescent hallways framing a warmer interior space. While post-production could give you separate white balances for each area, contrasting them like this is part of the creative idea.

Set a Creative White Balance

↓ Don't fight it
Since sodium vapor is almost impossible to white balance for anyway, indulging in its rich, golden yellow color cast can give roadways and street scenes a supernatural effect.

White balance is an amazing tool that lets you step into any lighting situation and then balance the sensor's color response to that specific light source. But this control can also be used as a creative weapon to intentionally mislead the sensor about the color of the ambient lighting. Because the "cloudy day" setting adds warmth, you can also use it in the neutral light of a midday sun to add a feeling of warmth—to a portrait, perhaps.

By telling the camera that you're shooting in tungsten light when, in fact, you're shooting in clear sunlight, it will supply extra blue color to the mix. This combination produces a day-for-night Hollywood effect and it's one of the ways that you might respond to this challenge. Think about the color of the light source and how adding light of a different color (or more of the same color) might affect the outcome. What creative visions do you see?

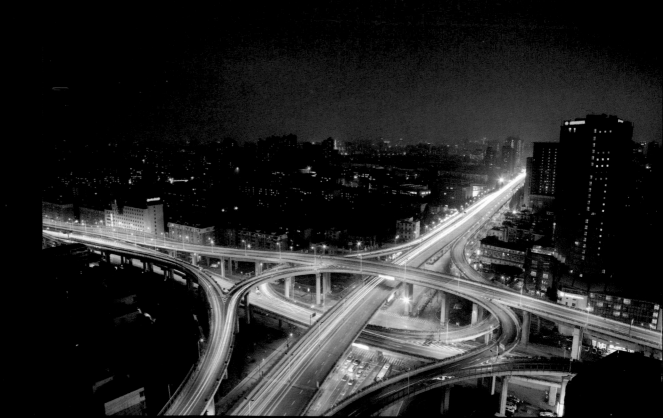

→ Feeling blue

While white balancing off the snow or ice would have given an accurate coloring, the result wouldn't have had the same chilling effect that this blue color cast gives, which was achieved with a tungsten WB setting.

Challenge Checklist

→ If you want to experiment with the full spectrum of white-balance options, just shoot in Raw and you can adjust the white balance during editing.

→ Use a little reverse psychology when intentionally setting a creative white balance: You know that the tungsten setting will add more blue to cool off tungsten lamps, but what would happen if you went the opposite direction and added even more warmth?

→ One of the goals of a correct white-balance setting is to render white subjects as close to a pure, un-tinted neutral tone as possible, but don't be restricted here by correctness. If a white church comes out as blue in your twilight effect, so be it.

→ If your camera has the capability, experiment with adjusting the color balance using the color picker found in the white balance menu.

Review

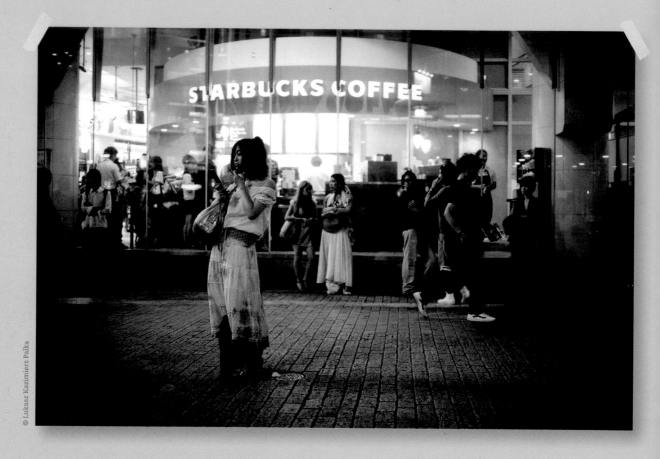

© Lukasz Kazimierz Palka

Here, I set the white balance to fluorescent and cranked the fine adjustment to Maximum Cool to match the girl's demeanor. It also plays beautifully with Tokyo's night lighting, which is a mix of fluorescent and incandescent lamps. f2 at 1/200 second, ISO 3200.
Lukasz Kazimierz Palka

Central Tokyo night-life districts like Shibuya and Roppongi are the quintessential "city-lights" settings, and you made a good choice for exaggerating the color. In particular, by pushing the color in the darker foreground area you give it a visual prominence that it might otherwise have lost to the coffee shop behind.
Michael Freeman

© Nathan Biehl

To evoke a more somber mood fit for this New Orleans cemetery, the white balance was pushed toward a cooler low color temperature. f4.2 at 1/125 second, ISO 100.

Nathan Biehl

This is effective for an atmospheric old southern cemetery, giving just the right amount of unexpected color without seeming exaggerated. The out-of-focus edge at right bothers me, though—not that it's out of focus so much as it's so close to the frame edge. I would crop that and then the bottom to preserve the aspect ratio.

Michael Freeman

Advanced Exposure Methods

Once you have a basic understanding of how light is measured and how your camera's exposure controls affect the look of a photographic image, you're well on the road to capturing good exposures of most average situations. And it's nice to be able to venture forth into the world with your camera knowing that you have the skills to accurately—and even creatively—capture these everyday situations.

Unfortunately, the world is full of interesting photographic possibilities that lay well beyond the concept of average. In fact, some of the best and most visually dazzling of potential photo subjects are anything but average—and, in many cases, it is their extreme nature that attracts us to them. Indeed, the very things that make a subject visually stimulating—intense contrast, flamboyant natural-light situations, and offbeat artificial-lighting sources and situations—are by their nature exceptional. How can you record contrast that is beyond your camera's dynamic range? How do you deal with the shadows falling across a portrait subject's face on a bright, sunny day? How do you expose for both a bright sky and a dark foreground in the same view?

These are the situations where your creative ambitions challenge your technical skills to reach a higher level. And these are also the situations that call on a more advanced set of exposure techniques. Once mastered, however, these techniques will prepare you to face any exposure challenge whether average or extraordinary.

Handling Extreme Contrast

© duoduo

As we discussed in the opening chapter, your eyes are able to see and manage a far broader dynamic range than can your digital camera's sensor. Given just a few seconds to adjust, your eyes are able to see and resolve great detail in both the darkest shadows and brightest highlights—a range that approaches the equivalent of nearly 24 stops of light. And because when you view a scene, your eyes are continuously shifting from one portion of a scene to another, your brain is able to process that range of contrast almost instantly. Pity your poor sensor, however, limited to a finite range of tonalities—and a range, quite honestly, that's often not adequate to the task at hand.

In fact, with the exception of very low-contrast situations (a foggy or overcast day, for example), most daylight situations in full sun are already pushing the limits of what your camera can handle. And once you get beyond those limits, important decisions have to be made about what is to be safely preserved and what must be jettisoned beyond the far edges of your histogram. Knowing how to make those sacrifices, what tools are available to deal with extreme circumstances, and which choices work best photographically will help keep you from throwing the baby out with

↑ Consider what's important
If the purpose of this photograph had been to accurately represent the full textural detail of each of these dark chairs, it would be a failure. But instead, the purpose was to create a graphic image of strong contrasts, and so the shadows in the seats were allowed to fall into pure black.

the bathwater, or, in this case, losing important subject detail for the sake of exposure. Fortunately, there are ways to not only record your subject accurately, but also to take creative advantage of the challenges at hand.

Contrast Control: Tools & Techniques

As you venture into the world of more complex exposure challenges it's important to know that there are a number of tools and techniques that you can use to help you solve the contrast riddle. Some of these solutions are camera-based (exposure compensation, for instance) while others rely on accessories and light modifiers. Not every tool works in every situation, of course, so it pays to experiment and be familiar with each of them.

Exposure Compensation

Very often the solution to an exposure problem is by adding or subtracting exposure from the metered exposure setting. The simplest way to do this is by using your camera's exposure compensation feature. This feature lets you add or subtract exposure regardless of what exposure mode you're using or what metering mode is measuring the light. Typically, you can add or subtract exposure by anywhere from three to five stops in one-third stop increments.

Exposure compensation is often used in conjunction with specific types of selective metering such as Center-Weighted or Spot metering (see pages 74–75). By carefully measure specific areas of a scene and then using exposure compensation to adjust the overall exposure, you can manipulate the tonal values of specific areas within a scene to suit your needs.

Keep in mind, however, that exposure compensation can't magically add or subtract exposure without affecting one of your exposure controls. In Aperture Priority mode, exposure compensation will adjust the shutter speed; and in Shutter Priority mode, it will adjust the aperture. This has two important consequences: one, you need to consider the affect a change in one or the other exposure control will have on your shot, in terms of either depth of field or how motion is captured; and two, there is no such thing as exposure compensation when you are in Manual exposure mode, as you are controlling every aspect of the exposure. If you want to brighten or darken a scene, you have to directly do so by changing the shutter speed or aperture (or ISO).

↓→ A simple fix

The abundance of direct sunlight made the original photo, on the right, underexposed. A simple exposure compensation of +1.5EV brightened up the umbrella and livened up the shot.

© Tomas Hajek

Adjust with Exposure Compensation

↓ Edinburgh Castle
The camera wanted to expose this shot so the castle was bright and evenly lit, but the original impression was much darker and moodier, which was mimicked by a negative exposure compensation.

Easily one of the handiest controls built into your camera is the exposure compensation control. Using this control saves many tedious moments of having to meter a scene in the Manual exposure mode and then pulling the camera away from your face to reset the controls. Exposure compensation shines most when you combine it with your knowledge and experience in setting exposure for difficult but common subjects.

For this challenge, you will need to find a subject that would typically fool the status quo of the meter. If you're photographing snowscape scenes, for example, use the compensation control to see just how much extra exposure is needed to record the snow as a clean white with texture and detail. Getting to know how much compensation is purely a matter of trial and error—so here's your chance to build your experience.

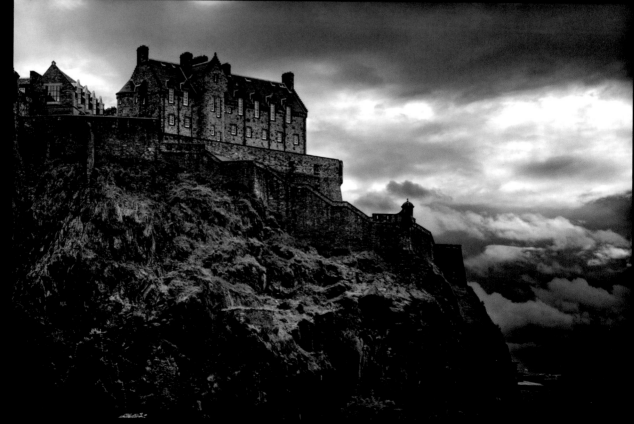

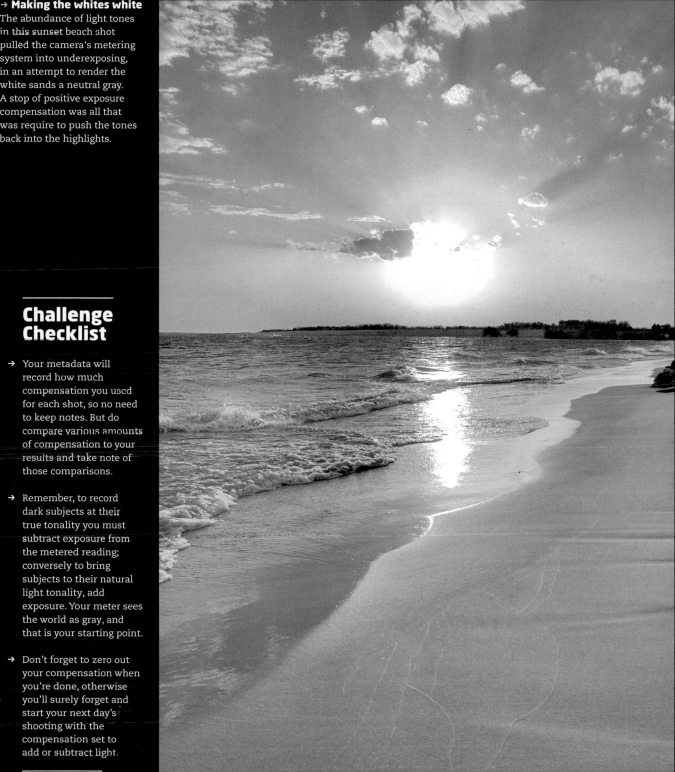

→ Making the whites white

The abundance of light tones in this sunset beach shot pulled the camera's metering system into underexposing, in an attempt to render the white sands a neutral gray. A stop of positive exposure compensation was all that was require to push the tones back into the highlights.

Challenge Checklist

→ Your metadata will record how much compensation you used for each shot, so no need to keep notes. But do compare various amounts of compensation to your results and take note of those comparisons.

→ Remember, to record dark subjects at their true tonality you must subtract exposure from the metered reading; conversely to bring subjects to their natural light tonality, add exposure. Your meter sees the world as gray, and that is your starting point.

→ Don't forget to zero out your compensation when you're done, otherwise you'll surely forget and start your next day's shooting with the compensation set to add or subtract light.

Review

© Nathan Biehl

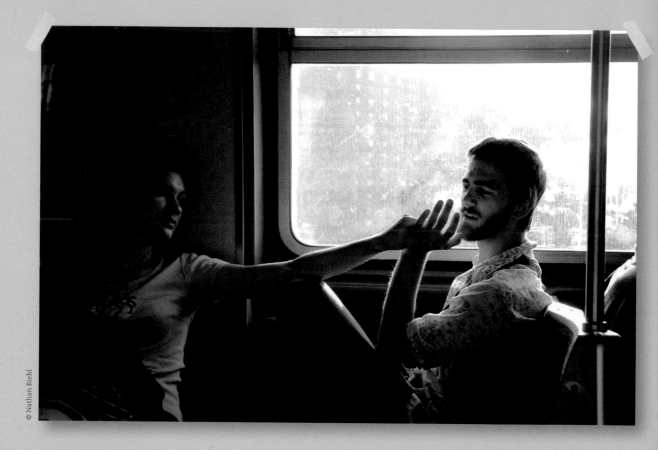

To compensate for the direct sun through the train's window, I set the exposure compensation to +2.7EV to reveal the couple's features. f4.2 at 125 second, ISO 200.
Nathan Biehl

That's certainly the right choice of compensation—holding his face while not losing too much of her face in the shadow. You don't say what prompted you to that exact figure of +2.7. Was that experience, an informed guess, or did you try different amounts of compensation in other frames?
Michael Freeman

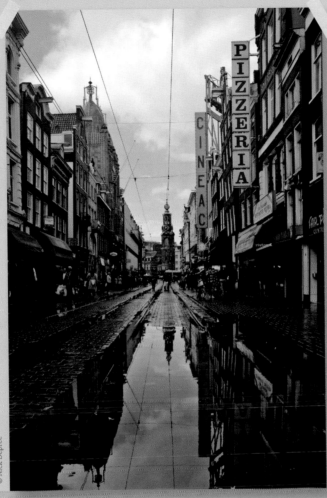

© Nick Depree

Regulierbreestraat, Amsterdam. With a bright sky, dark buildings, and reflective foreground in the rain puddles, I checked the LCD and made an adjustment of -1.3EV to retain detail in the highlights, particularly in the sky. f8 at 1/1600 second, ISO 800.

Nick Depree

I can see you had time to work this out, so you took the opportunity, and rightly identified the brighter areas of the clouds as being important to hold back from clipping. Reflections are typically at least a stop darker, so no issue there.

Michael Freeman

Reflectors & Diffusers

Adjusting the exposure in-camera alters only its response, not the actual lighting. A simple way to moderate contrast with close subjects (again, portraits, still lifes, close-ups, etc.) is to use reflectors or diffusers to adjust the intensity of the existing light. Portable reflectors, for example, enable you to bounce a controlled amount of light into the shadowed side of a backlit subject in order to reduce the contrast between the brighter backlighting and the dimmer shadow areas.

For example, if you're photographing a head-and-shoulders portrait and you are using backlighting (light coming from behind your subject) to create a rim-light effect on their hair, the face will fall into relatively dark shadow. By aiming a small portable reflector at the face, you can use the same light that is creating the halo to kick light into your subject's face. Bouncing light into the face in this way (or even into a close-up of a wildflower) reduces contrast by balancing the light between foreground and background. You can adjust the intensity of the reflected light by moving closer to or farther from the subject, by adjusting the angle of the reflector relative to the light source, or by changing the color of the reflector.

There are a number of commercially made collapsible reflectors that come in silver, white, and gold, and many are reversible. These reflectors collapse so that they are small enough to pack in a camera bag and then pop out to their working size. You can, of course, also make your own reflectors with fabric or foil, and they work just fine. But the

beauty of collapsible reflectors is that they fit nicely in a camera bag or vest pocket. Using a reflector is a lot simpler if you have a friend or assistant to hold it, or if you put your camera on a tripod so your hands are free to hold the reflector yourself.

Reflectors don't use batteries, and are very easy to use, as you can directly observe their effects in real-time

(unlike fill flash, discussed on page 102). It takes a minimum amount of experimentation to become completely fluent with how they operate. For larger subjects (group portraits, or full-body portraits) you can also buy reflector panels in much larger sizes. Typically these stretch to fit a collapsible, lightweight frame, and can be mounted to a stand or support.

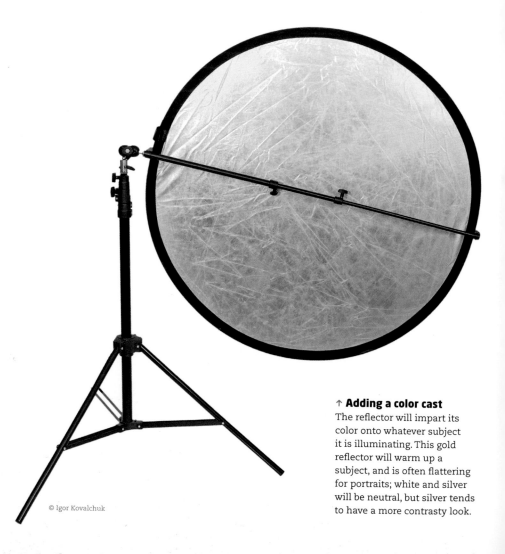

© Igor Kovalchuk

↑ Adding a color cast
The reflector will impart its color onto whatever subject it is illuminating. This gold reflector will warm up a subject, and is often flattering for portraits; white and silver will be neutral, but silver tends to have a more contrasty look.

Diffusion Panels

Diffusion panels are available in similar shapes and sizes as reflectors, but are placed between the light source and your subject. The purpose of a diffusion screen is to soften both the look and the intensity of the existing light. It does this by broadening the light source—instead of a point source (like the sun), the panel itself becomes the light source. Fashion photographers frequently use diffusion panels when photographing models in harsh lighting situations (a bright sunlit beach, for instance) because they soften the look and intensity of the light but typically only have minimal effect on the brightness levels.

The important thing about using diffusion panels is to be sure that they are diffusing the light evenly across your entire subject. If you are using a small handheld diffuser to soften the light falling on your subject's face in a head-and-shoulders portrait, it's important that the diffusion is equal across the entire face, or at least is feathered gently so that the fact that you are diffusing the light isn't too obvious. Also, if the panel that you're using isn't softening the light enough, you can try doubling up on the diffusion fabric to reduce the intensity of the existing light even further.

© Igor Kovalchuk

↓ **Bright in front, bright behind**
By reflecting light up onto this subject's face, she is properly exposed while still allowing the background to be very bright and cheerful.

→ **Because sometimes there's no assistant**
You'll often want to be constantly manipulating your diffusers and reflectors, but for close-up work, a tripod stand can work just fine.

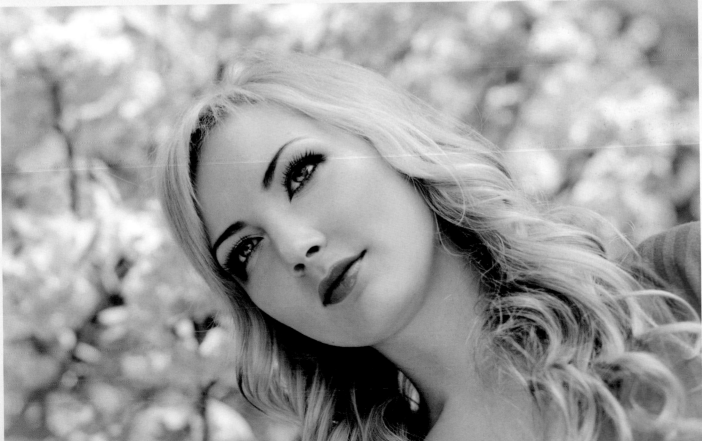

© Denys Kurbatov

Tackling the Shadows

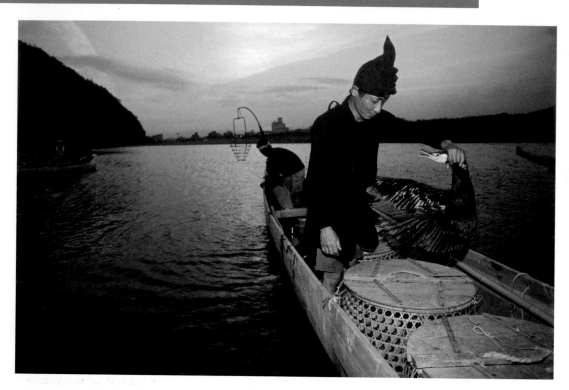

← Keeping the context
There are two important areas of this frame: the foreground, with the backlit cormorant fisherman at work; and the distant background, with a beautifully saturated sunset reflecting off the waters. Unfortunately, these two areas require completely different exposures, so a flash was fired to fill in the foreground and balance its exposure with the dim conditions of the setting sun. The result captures the human subject while still preserving his surrounding environment and context.

Fill Flash

Whether you're using your camera's built-in flash or an accessory flash unit, fill flash is a very convenient and predictable way to moderate the contrast of many nearby subjects—particularly portraits. Fill flash lets you increase the illumination of dimmer or more shadowed areas ("filling" them in with light) while maintaining the overall exposure suggested by your camera's meter. In effect this reduces the contrast between the brighter and dimmer parts of a scene—though, of course, it only works with relatively nearby subjects that are within the distance range of the flash, which varies from one model to the next.

In a strongly backlit portrait, for example, if you are not careful to exclude the bright light around your subject, the excess brightness of the background light will cause significant underexposure in the face and on the front of your subject. If you compensate for the shadow areas (the face) by adding exposure, then you will wash out a lot of the background detail. Just as a reflector can bounce that backlight back into the portrait's face, a flash can add new frontal light to achieve the same effect.

Most flash units (both built-in and accessory units) enable you to control the ratio between the flash and the ambient lighting. By setting your flash to provide -1 stops of illumination, for

example, you are using the camera's metered reading for the overall exposure and then adding a flash fill that is one stop less bright. This creates a more natural balance between the existing light and the flash. If it is too obvious, you can soften the effect of the flash by attaching a flash diffuser.

If you are using your camera's built-in flash unit, read your camera manual to see how to set the flash compensation feature to control the intensity of the flash exposure. Keep in mind that the flash compensation feature only controls the flash output relative to the ambient lighting; you can still use the exposure compensation feature to add or subtract light from the main exposure.

Graduated Neutral Density Filters

One contrast problem that landscape and travel photographers often encounter is a situation where the foreground is much darker than the sky. This happens a lot in mountainous areas where the foreground is lost in the shadow of mountain peaks, but the sky is still brightly lit, which creates a contrast gap that's nearly impossible to resolve (there isn't a reflector big enough or a flash powerful enough to fill in a whole mountainside). The problem is that if you expose for the foreground, the sky will wash out; and conversely, if you expose for the sky, the foreground will be hopelessly dark.

Unable to add sufficient light to balance the exposure, the only other option is to take away light from the brighter areas of the frame. In such a case, the best solution is to use a graduated neutral density (ND) filter. Graduated ND filters have the same effect as normal ND filters, in that they block specific amounts of light from reaching the sensor without contributing any color casts, except that the amount of light held back varies across the frame. Looking at a square graduated filter held horizontally, for example, the density begins very lightly at the center of the filter and then transitions to full density by the time it reaches the top edge of the frame. By placing the density over the sky area (which is too

bright), you bring its brightness levels down closer to the foreground areas (which were too dark).

As with full ND filters, you can buy these in varying strengths. Some manufacturers also make graduated filters with a color tint so that you can warm the sky area, for instance. Graduated ND filters are available as both screw-in filters in a rotating mount or as drop-in square filters that attach to the lens via a filter frame. The latter are probably more practical because they enable you to carefully position the line of demarcation between density and clear filter by sliding it up and down to line up with the horizon line.

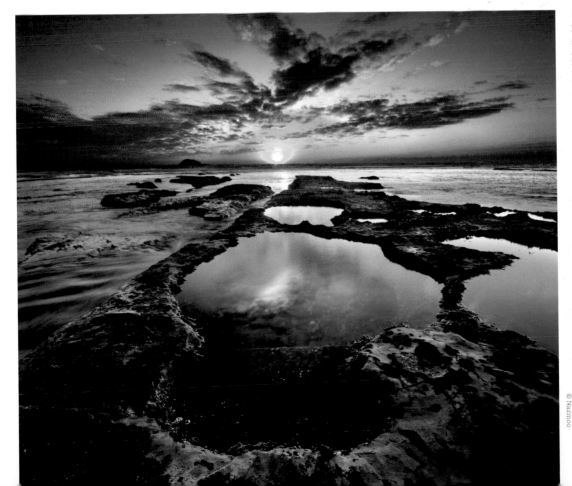

← Darkening skies

In landscape shots with bright skies, the more foreground you include, the greater the likelihood that there will be too much contrast between the ground and the sky to fit all the tones into a single exposure. In this case, a graduated ND filter was positioned so that the sky was darkened by -2 stops, which brought its brightness levels down to almost equal those of the interesting foreground elements, allowing a single exposure to capture the full range of tonalities.

© Nazmoo

High Dynamic Range Imaging

One of the more innovative approaches to solving the extreme contrast riddle has been the ascent of an extremely popular technique called High Dynamic Range Imaging (HDRI). HDRI is simply a process whereby the entire dynamic range, however high, is captured in a sequence of different exposures, and then all of them are combined into a single image file. So far, so good, but this combined image file (saved in a special format such as RGBE or OpenEXR) can still not be viewed on a normal computer or television screen. It needs a second stage of being converted back to a viewable image by a process known as tonemapping, in which you decide where exactly to distribute the full tonal data that you've collected throughout the limited dynamic range capacity of a given viewing platform (i.e., a paper print or a digital display).

The simplest way to capture the requisite exposures is to set your camera to its Autoexposure Bracketing mode, in which the camera will take a series of shots (i.e., a bracket) with only one being at the proper exposure (as determined by the metering system), and the others covering some predetermined range of over- and underexposure. You can usually set precisely the range covered by your bracket in your camera. Typically, a three-shot +/-3EV bracket is sufficient—this means that the first exposure will be properly metered, the second will be overexposed by +3EV, and the third will be underexposed by -3EV. The effect is that you have now expanded your dynamic range by six stops: 3 in the highlights, and 3 in the shadows. Depending on your camera's ability—and the amount of processing power available in your computer—you can

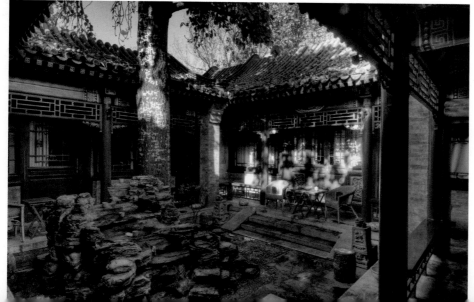

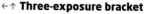

←↑ Three-exposure bracket
This courtyard of an old hutong dwelling in Beijing presents a classic high-dynamic range situation: Bright midday sun is streaming in through the open area at the top of the frame, casting deep, black shadows along the left half and far right of the frame. As the intent of the photograph is to accurately represent this architectural space, a dramatic interpretation is inappropriate; so the best exposure option was to bracket three exposures—one for the highlights, one for the mid-tones, and one for the shadows—which were then combined into a single image in Photoshop.

shoot extremely wide brackets of, say, a dozen shots covering a vast range of tonal values, but this is almost always going to be overkill. Usually, expanding your camera sensor's native dynamic range a few stops in either direction is sufficient, and the resulting files will be much easier to process.

HDR Processing

There is no shortage of post-production software options available for combining your bracketed exposures into a single HDR image, from dedicated programs like Photomatix (www.hdrsoft.com) to built-in tools and plugins available in Adobe Photoshop or Lightroom. Regardless of the software used, the basic process is quite straightforward, and is fundamentally a matter of deciding where to put what information from which exposure in the final image. For instance, in Photoshop you are given three basic options: Equalize Histogram, which globally spreads out all the exposure information gathered across the full frame; Highlight Compression, which attempts to restore blow-out highlights of one exposure with detail from another; or Local Adaptation, which gives you the most control and allows you to construct a custom tone curve to most accurately spread out your exposure information across various areas of the frame.

If you begin to explore HDR imaging in full, you will soon realize that the abundance of information captured across multiple images can be combined in many more ways than one, and that given such a wealth of exposure options, your rendition of your final image quickly becomes a matter of personal, creative interpretation. It becomes very easy to push what was a normal scene far into the bounds of heavily processed, surrealistic artistry. However, it's strongly recommended that you begin by performing the most photorealistic processing that you can. For one, that is much closer to the purpose of this book (i.e., using HDRI as an exposure tool, first and foremost); and second, because it is all too easy to get carried away with surrealistic interpretations, it's best to establish a firm foundation before moving on to higher levels of experimentation.

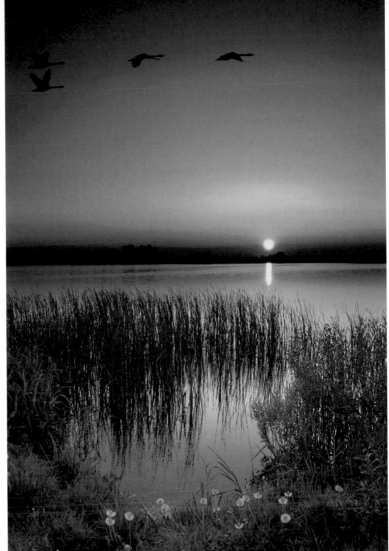

© Jarosław Grudziński

↑ Improvised ND filter
This sunset scene required heavy underexposure to capture the rich tones of the sky in the upper half of the frame, but need a boost to the exposure in order to get any detail in the foreground marshes. An ND filter would have been ideal, but—as you've no doubt discovered—you won't always have the perfect gear on-hand for every shot. In such a case, a manual, two-exposure bracket was the practical choice: one for the sky, one for the marshes.

Combat the Contrast with an HDR Image

↓ Balancing land and sky

The severe underexposure required to capture the rich, saturated tones in the sky meant the foreground dock would have to be almost pure black. So a simple HDR combination of one shot exposed for the sky, and one shot exposed for the foreground, meant all the tones could fit into a single, final image.

Although the sensor in your digital camera has a finite dynamic range, that only means it can only record a certain tonal range in one frame. And that is the secret to this challenge: You will make separate exposures for two or more distinct tonal regions of your scene and then combine them into one HDR image in editing. The final photo will contain a tonal range that greatly exceeds the limitations set by your camera.

So for this challenge, rather than turn away from extreme contrast, you'll want to seek it out—and the wider the contrast range, the better. You must then use your editing skills to combine the images using your normal editing program, or a dedicated software like Photomatix. But either way, your goal is the same: Tame the contrast by expanding the dynamic range of your images.

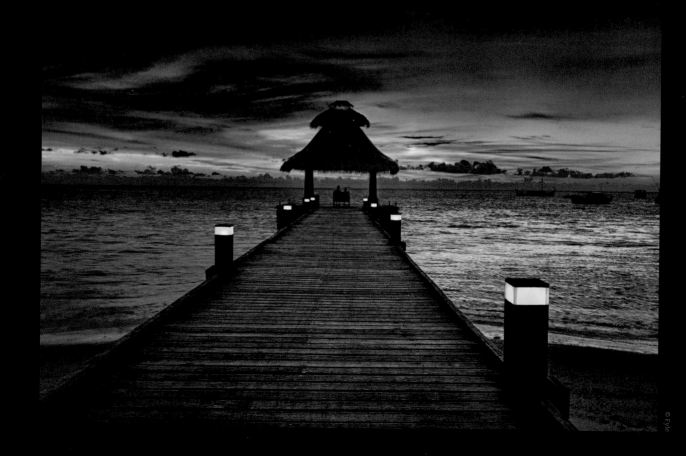

© Fyle

→ **Go for a graphic take**

This shot demonstrates a subtle use of HDR, in which one shot is exposed for the outside and pillars, with a second capturing detail in the graphic pattern along the vaulted roof at the upper-left of the frame.

Challenge Checklist

→ You'll definitely need your tripod for this challenge because the multiple frames must fall into perfect register.

→ One fast way to fire off several shots at various exposures is to use your autoexposure bracketing feature. Just be sure that the primary exposure is set correctly for the mid-tones, and then bracket widely enough to capture images of both the shadow and highlight areas.

→ If your camera has a built-in HDR mode, try it. But try to create the multiple exposure manually too, and then compare the results.

Review

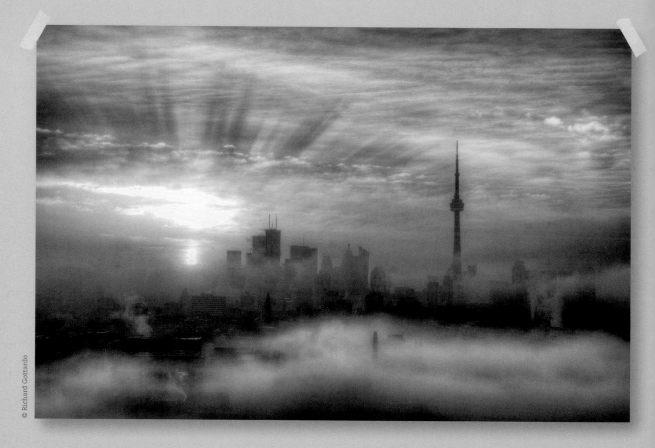

© Richard Gottardo

To capture the sun as well as the shadows in the fog and buildings, three images were captured: one 2 stops underexposed for the highlights, one normal exposure for the mid-tones, and one 2 stops overexposed for the shadows. These pictures were then merged together to form one HDR image.
Richard Gottardo

I have to say I really like this, and I'm no fan of steroidal HDRI. The shadows on the high fog layer are what makes it special, and so yes, some HDR techniques were essential. What I would like to know is how you approached the tonemapping—local or global, and what settings?
Michael Freeman

© Nick Depree

Atomium, Brussels. HDR worked well for this shot to expand the detail reflected in the steel spheres, giving a nice metallic look and strong sky behind.

Nick Depree

Yes, it pulled out the reflected detail well, and yet still retains a natural, photorealistic look. Again, I'm curious about how you achieved this effect, in terms of your tonemapping workflow.

Michael Freeman

The Zone System in a Digital World

One of the pioneers of creative exposure was the American landscape master Ansel Adams. In addition to redefining nature photography through his powerful wilderness compositions, Adams, perhaps more than any photographer before him, elevated the principles of exposure to a high skill. It was his articulate writings on the topic of vision, exposure, and their interrelationships that have now given generations of photographers a thorough understanding of the power of exposure.

In 1939–40, Adams and fellow photographer Fred Archer created an exposure method called the Zone System—a system that provided a means by which one could use the tools of exposure to predictably translate their personal vision to the final print. As even Adams explains, however,

it wasn't so much an invention as a "codification of the principles of sensitometry." Adams also coined the term "visualization" (often misquoted as "pre-visualization") to describe this process of translating one's vision to the final print. Finally, Adams used the Zone system in conjunction with under- and overprocessing, which with film and when combined with the appropriate amount of over- and underexposure, respectively, altered the contrast of the negative. The digital equivalent is much simpler—i.e., at its most basic, altering the tone curve.

Though originally developed for use as an aid in exposing and printing black-and-white negative films, the core aspects can be adapted very well to digital photography. And though many books have been written on the Zone System and some have made it

appear hopelessly complex, it isn't. In fact, understanding and applying the basic premise can make getting a good exposure—even with your digital camera—a very simple process. Moreover, it creates a reliable and fast method for placing tones exactly where you want them in your photos. The fundamental concept of the Zone System is that the world around us could be divided into 10 distinct tonal values (though there are a few variations of the system that use either 9 or 11 values). The values range from zone "0" which is pure black with no detail to zone "IX" which is pure white with no texture at all. The middle tone in this system is Zone V and it represents a midway point that is exactly halfway between pure black and pure white. As we discussed briefly earlier, this middle zone is what photographers refer to as "middle gray."

© Dmitry DG

© Florelena

© Kaowenhua

← **Zones III, V, and VII**
Digital photography saves you a lot of time concerning yourself with all 10 distinct tonal regions and their associated definitions. In fact, once you understand the principles of the zone system, you can concentrate mostly on just these three zones. They are significant in that each maintains texture and detail, and that Zones VII and III (far left and far right) will always fall on either side of your metered target (Zone V—the leaves in the center).

Here is the interesting aspect of the 10 distinct tonal representations on the Zone System scale: Each zone in the scale represents a tone that is either half as bright or half as dark as the one adjacent to it (depending on which direction you're moving). As you should remember from our discussion of basic exposure controls, each time that you move from one exposure stop to the next, you either halve or double the amount of light getting to your sensor. And as you have probably guessed (and correctly so), each time that you change exposure by one stop (again, either aperture or shutter speed) you shift every value on the Zone System scale to the next value. In other words, every zone on the

scale is exactly one stop away from the one next to it. By shifting exposure, you can shift exactly where specific tones land in that 10-stop tonal range. If, for example, you meter a subject of a particular value (let's just say a red apple), you are placing it on Zone V. But if you open the lens by one stop (or slow the shutter by one stop) the apple would be placed one tonal step lighter. Instead of being placed on Zone V, it will now be shifted to Zone VI. The reverse is also true: Close the lens by one stop (or make the shutter speed one stop faster) and the apple is now placed on Zone IV—exactly one stop darker. You can see the power this gives you over the tonal placement of any subject—and it is an exacting science.

The beauty of this system is that you know that whatever you meter is going to land on Zone V. To make it darker, all you have to do is underexpose from that meter reading. To make it lighter, increase exposure. It doesn't matter whether you adjust shutter speed or aperture, but for each stop that you alter the exposure, you shift every tone either up or down the tonal scale. Your creative decision is on the initial placement of your mid-tone; then all the other tones fall into their respective zones. That's the Zone System workflow: Place, then fall. Combine judicious mid-tone placement with a full understanding of where the rest of the tones will fall as a result, and you'll master the Zone System in no time.

The Zones

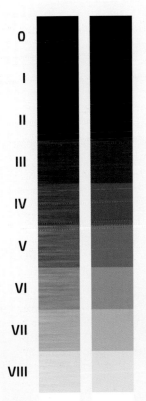

An alternative version of the Zone System has 11 zones instead of the 10 shown here, and yet another has 9. Note that we show two versions of the scale here, one of solid tones, the other with an added texture. One school of thought holds that textured zones are closer to the reality of a scene, and so easier to judge.

ZONE 0	Solid, maximum black. 0,0,0 in RGB. No detail. In digital photography, the black point goes here.
ZONE I	Almost black, as in deep shadows. No discernible texture. In digital photography, almost solid black.
ZONE II	First hint of texture in a shadow. Mysterious, only just visible. In digital photography, the point at which detail begins to be distinguished from noise.
ZONE III	**Textured shadow.** A key zone in many scenes and images. Texture and detail are clearly seen, such as the folds and weave of a dark fabric.
ZONE IV	Typical shadow value, as in dark foliage, buildings, landscapes.
ZONE V	**Mid-tone.** The pivotal value. Average, mid-gray, an 18% gray card. Dark skin, light foliage.
ZONE VI	Average Caucasian skin, concrete in overcast light, shadows on snow in sunlit scenes.
ZONE VII	**Textured brights.** Pale skin, light-toned and brightly lit concrete. Yellows, pinks, and other obviously light colors. In digital photography, the point at which detail can just be seen in highlights.
ZONE VIII	The last hint of texture, bright white. In digital photography, the brightest acceptable highlight.
ZONE IX	Solid white, 255,255,255 in RGB. Acceptable for specular highlights only. In digital photography, the white point goes here.

The Zone System in Practice

Let's put this in practical terms. Imagine that you are photographing a white swan sitting on a dark, muddy river bank. If you were to use your Center-Weighted metering mode to take a reading of just the swan, the meter would place the bird's feathers at Zone V—or middle gray. The muddy bank that the swan was on would probably fall to a Zone I or II which is black with virtually no detail. Those tonal placements are exactly what the meter was designed to do and by placing the values at those zones it is doing it's job very well.

The problem with this particular scenario (as you've no doubt noticed) is that what you've now got is a gray swan—and you won't win any awards with an ash-colored swan. And the mud, which certainly had some interesting texture in person, is now a black blob without any surface detail or texture at all. In other words, what you have is a gray swan sitting on a black blob. Not terribly appealing.

Let's say, however, that you want the swan to fall into Zone VII—which is white but with some surface detail and is probably a good placement for a white subject. By increasing your exposure by two stops (again, either by opening the lens aperture two stops or slowing the shutter speed by two stops) you've now shifted the swan to a more proper white tone.

But what about the dark mud that the swan was sitting on? Because you have increased the exposure by two tones to lighten the tonality of the swan, you have also raised the tones of the mud up to a Zone III or IV—a dark gray but with perceptible detail. Now the swan and the mud are much closer to the way in which you envisioned them tonally. The Zone System at work.

One way to adjust exposure in these situations, by the way, is to use your exposure compensation feature (see page 97). The problem with doing this, however, is that you may not be given a choice as to whether your camera adjusts the shutter speed or the aperture. Alternately, of course, you could use your Shutter Priority or Aperture Priority exposure modes in which case you can control which exposure setting is being changed.

You can work the system in the opposite direction, too. If you are photographing a model in a black dress, for instance, the client will no doubt want their dress as black, not a middle gray. If you meter directly from the dress, however, you are placing it on a middle tone. By then subtracting exposure from the meter reading, you are placing the dress back to where it belongs on the tonal scale.

The system works just as well with a more complicated scenes such as a landscape, and really that goes to the other principle of Adams approach to exposure: visualization. By looking at complex scenes and then mentally breaking them down into tonal regions, he was able to visualize exactly how shifts in exposure (and, because he was using film, the developing process) would affect each of those areas. Adams knew, certainly, that each tone did not exist as a separate area within a scene, and that tones merged gradually into one another, but it was nevertheless a major aid in thinking about not just accurate exposures, but also potential creative interpretations of that accurate exposure.

In realistic digital terms, there is much more "play" in exposure with digital than with film. By making a simple curves adjustment in editing, for instance, you can shift a white swan or black dress to almost anywhere on the tonal scale that you want it. But, with the possible exception of adjusting exposure with Raw files, few exposure adjustments that you make in editing come without a price—the very least of which is the time spent making the corrections in the first place. And the larger price is that (again, with the exception of Raw changes) you are also tossing way a certain percentage of pixels from the recorded image.

In short, the more precise your placement of tonal values are in the camera, the higher quality your final adjusted image will be.

© Catolia

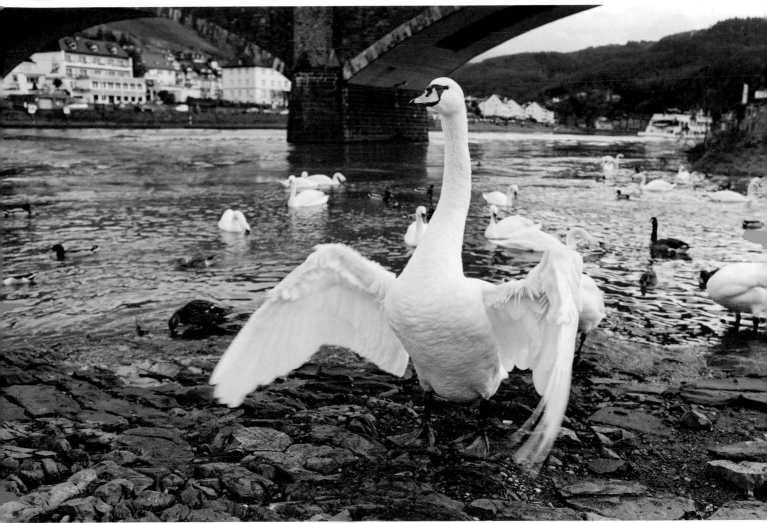

↑ Zone VII: textured brights
In all of these B&W images, the referenced zone appears as pure white. In this case, the majority of the swan appears as a bright tone, but one that still maintains its texture and detail.

↑ Zone V: mid-tones
The slightly shadowed underbelly of the swan, along with some of the rocky foreground and much of the river and city beyond, is captured as a middle gray.

↑ Zone III: textured shadows
The darkest areas of the frame—most of the foreground and the bridge arches midway into the scene—still preserve all their important textures and details.

Mastering Creative Exposure

Once you have mastered the skills of recording a good range of tonalities, in situations both simple and complex, it may seem that the larger battle is won. And to a degree, it is—you can now feel confident walking into almost any lighting situation and emerging with, at the very least, an acceptable technical rendering of the scene. With a basic understanding of the relationship between apertures and shutter speeds, for example, you can dictate (rather than blindly accept) what is or isn't in focus and exactly how moving subjects are recorded.

The problem, however, is that while possessing these skills represents an admirable achievement, such straight renderings are rarely the evocative or artistic interpretations that your subject deserves—or that show your truest talent. Interestingly though, you don't have to wander far from the straight and narrow path of "correct" exposures in order to uncover some strikingly different results. By simply shifting your exposure a few stops toward under- or over-exposure, for example, the emotional climate of a scene changes radically. And by exposing exclusively for the highlights and throwing the shadows under the bus, so to speak, you can reduce common objects to their most fundamental shapes.

From this point forward you can (and should) see the basic tools of good exposure as a stepping-off point: a launching platform for transforming ideas into personal vision. It is from this starting point that you cease to imitate the accomplishments of others and begin to create images that are something entirely unique: the seeds of a personal style.

Low-Key Images

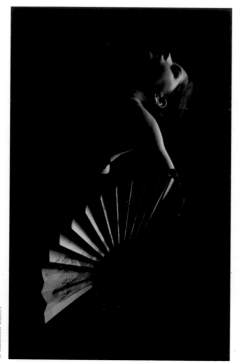

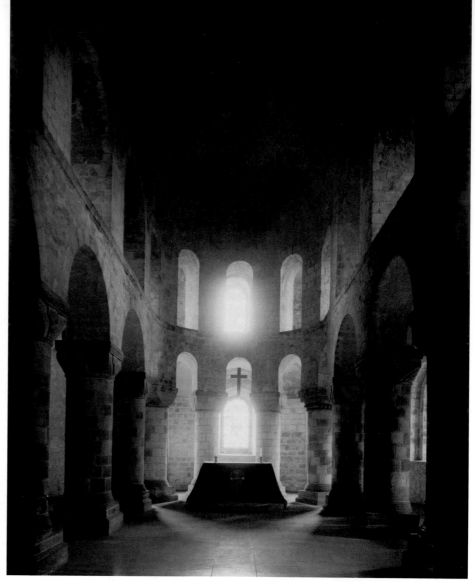

↑ Playing off the shadows
In this shot, there is just a faint trace of highlights along the model's upper arm and cheekbone. The colors all fall in the mid-tones or darker, and as they contrast against the pure black background and shadows they appear richer and bolder without actually undergoing any saturation boost.

↗ St. John's Chapel, Tower of London
Here, the deep shadows on this Norman chapel are allowed to contrast with the flaring sunlight through the window, in order to reproduce the actual sensation of this medieval architecture. Recovering the shadows, or filling them in with lighting, would have been out of character.

In most situations, the choices that you make in either accepting or altering the exposure settings your meter indicates are decisions made to place the tonalities of specific subjects where most viewers would feel that they normally belong. You're simply tweaking the exposure to correct for "Zone V" metering—adding exposure to keep white subjects white, for instance, or reducing exposure to keep dark subjects dark.

But there are times when diverging more aggressively from a middle-of-the-road exposure creates some very dramatic images. Typically, such extreme variations—either toward under- or overexposure—are made to enhance a specific type of subject or to exaggerate an emotional climate. There is, of course, always the choice that if you get too extreme in your variations that people will view your exposures as mistakes rather than creative choices, but it's only by experimenting that you can find the parameters of your own creativity.

Any time that a photograph is dominated by primarily darker tones and has a limited number of light or middle-toned areas, it's referred to as a low-key image. Low-key images can (and usually do) have highlights and, in fact, often need the contrast of limited brighter tones to establish contrast and better exhibit the richness of the darker regions. The overall tonal range, however, tends to be quite dark and very subdued—a portrait set against a dark shadow background or a still life made up of deep, rich colors.

Low-key photos tend to elicit a more brooding or melancholy emotional response because of their inherent darkness, and are often seen as mysterious or intriguing. Our eyes are curious about and tend to linger longer in dark-toned images because our brains are searching for clues about the missing brighter areas. Again, low-key lighting is a staple in Hollywood whenever a brooding or ominous mood is desired.

Extreme Underexposure

Imagine that you're photographing an approaching thunderstorm. Recording the tones as they appear may be enough to show that what you're photographing is a storm-laden sky. You can, however, greatly exaggerate that mood and intensify the drama of the moment if you intentionally underexpose the scene by two or three stops. By doing so, you will significantly reduce the scene to one of gray, almost black skies, and large areas of deep shadow. The entire image—including all but the brightest highlights—will shift into a palette of deep grays.

◤ Engaging product shots
Though it might seem counterintuitive to hide the main subject in a product shot, it is an effective technique for pulling in the viewer's attention—one well-used by art directors.

↓ Storms above the Isle of Skye
There isn't a single highlight in this stormscape, though the clouds, waterfall, and midground elements appear brighter by comparison. Limiting the palette to the left side of the histogram, elicits tension from the view.

The trick to recording very low-key scenes, however, is to not go so dark that you can't resolve a certain amount of minimal shadow detail during editing. If details in storms clouds are lost, it's probably of no concern, but if foreground details are reduced to pure black then you've lost all sense of texture and detail, and your image will lack a sense of place and context.

Such deep underexposure can also be used to subdue more colorful subjects, as well, in order to draw out the richness of the colors and also use darkened shadows to enhance surface textures. In photographing a street produce market, for instance, a "normal" exposure will record a colorful and cheerful scene. But by reducing the exposure several stops, shadows begin to dominate, people fall into dark shapes and the colored produce seem to be oddly abstract shapes. By making an extreme shift in exposure you've completely altered the mood of the moment—which is entirely your creative right as a photographer.

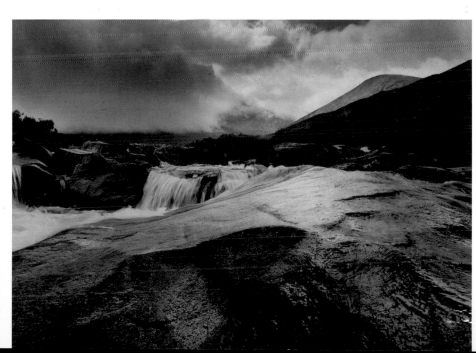

Shoot the Shadows with a Low-Key Shot

↓ Contrast is key
It's ironic how often a low-key shot is composed around a light source, but a shadow isn't a shadow without a contrasting area of light.

Dark and dreary, dank and gloomy, that's one way to think of a low-key shot. These images, built from the heavy building blocks of subjects lost in the shadow world are striking because of their heavy bias toward seemingly murky tonal combinations. But low-key scenes can also have a dramatic regal flair—a palette and lighting style through which Rembrandt brought illumination to his vision.

In completing this challenge you will no doubt discover that even the darker side of the tonal scale has its emotional light. Finding fodder for such ideas is not easy, it takes an ability to look on the darker side of the road. You have to see strength and emotion in places that are not screaming for your attention. But once you learn to design from the mid-tones down and embrace the shadow world, you'll find much visual magic hidden in those secret lairs.

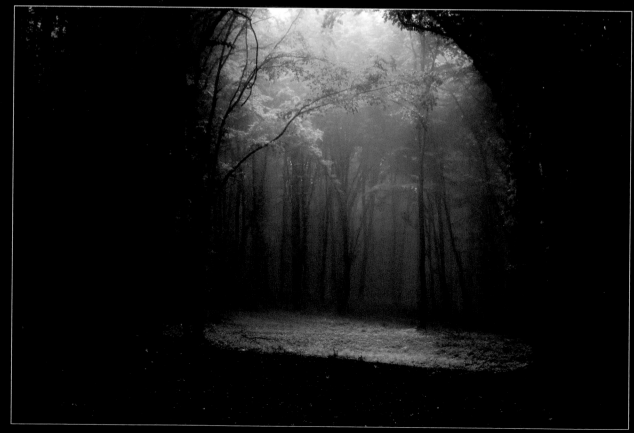

© Andreiuc88

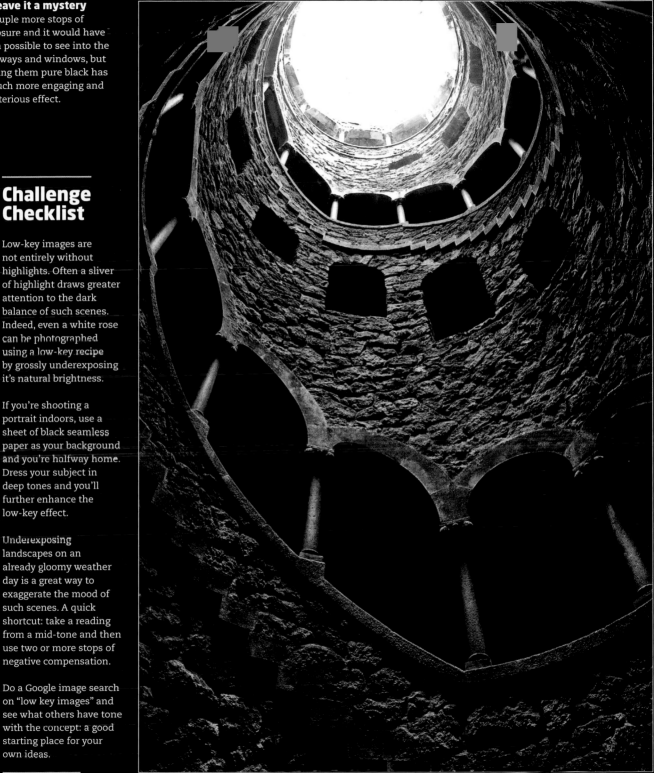

→ Leave it a mystery
A couple more stops of exposure and it would have been possible to see into the archways and windows, but leaving them pure black has a much more engaging and mysterious effect.

Challenge Checklist

→ Low-key images are not entirely without highlights. Often a sliver of highlight draws greater attention to the dark balance of such scenes. Indeed, even a white rose can be photographed using a low-key recipe by grossly underexposing it's natural brightness.

→ If you're shooting a portrait indoors, use a sheet of black seamless paper as your background and you're halfway home. Dress your subject in deep tones and you'll further enhance the low-key effect.

→ Underexposing landscapes on an already gloomy weather day is a great way to exaggerate the mood of such scenes. A quick shortcut: take a reading from a mid-tone and then use two or more stops of negative compensation.

→ Do a Google image search on "low key images" and see what others have tone with the concept: a good starting place for your own ideas.

Review

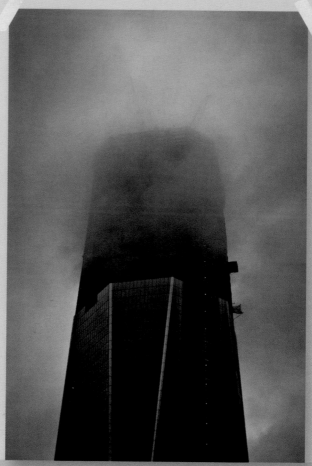

© Nick Depree

One World Trade Centre, New York City. This low-key shot on a misty day reveals the shape of the building behind the fog layer, giving an atmospheric view of a building project charged with emotion for many people.
f5.6 at 1/1250, ISO 400.
Nick Depree

The suggestion of cranes and equipment at the top of the building seems just right to me—the eye is drawn there to find out what exactly is going on. Lighter than this would have been a bit too obvious, and darker would not draw the attention upward.
Michael Freeman

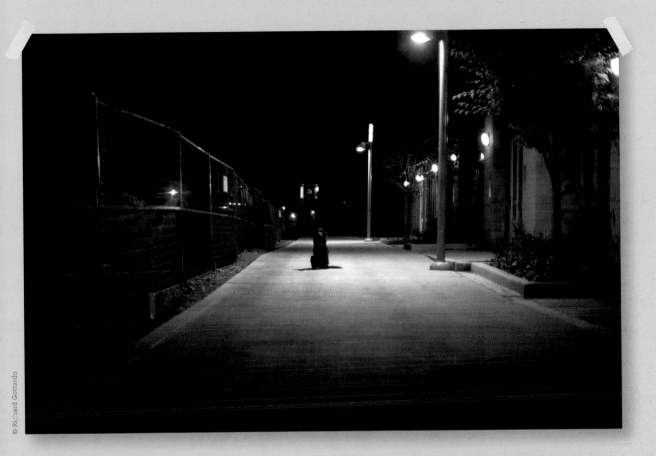

For this shot I want to emphasize the lonely feeling of the dog sitting alone. This was achieved by placing him underneath a street lamp in order to get some light on the dog while retaining the shadows throughout the rest of the frame.

Richard Gottardo

Definitely a worthwhile idea, although for me the effect is weakened somewhat by the placement of the dog (I assume he obeyed instructions). If he had been a couple of feet closer and to camera right (closer to the streetlamp), his head would not have been as lost in the background shadows as it is.

Michael Freeman

High-Key Images

A high-key image is one where the overwhelming balance of tones range between lighter mid-tones and the very whitest highlights. In exposing for high-key scenes, it's fine to let some of the brightest images wash-out completely, as this tends to enhance the airy and romantic look of the pictures. Again, it's not a fault to have a certain number of mid-tone or darker areas, but high-key images do work better when their contrast is moderate and dark tones are kept to a minimum. High-key images definitely tend to have a cheerful, upbeat quality to them. The technique is particularly well suited to portraits, both formal and informal, because it gives them a gentle, dream-like quality.

© Valua Vitaly

← High-key high fashion
There are two immediate side effects to this portrait's use of high-key lighting: the skin is so blown out that it needs no retouching in order to appear smooth; and the reds of the lips and fingernails are accented and emboldened.

↑ Cheery interiors
When photographing interior spaces—particularly domestic ones—it is often desirable to represent them positively, with a feeling of cleanness and comfort. Letting an abundance of light spill through the rooms achieves this.

Extreme Overexposure and High-Key Imaging

It's typically harder to find subjects that work well with overexposure because usually it means sacrificing a high percentage of highlights and lighter tones. Therefore, the idea of gross intentional overexposure works best with subjects that are atmospherically or emotionally matched to the technique—yellow and white flowers swaying in a summer breeze, for example, or girls in white-cotton dresses dancing through a meadow. In these situations, mood trumps highlight detail and if you capture the right moment, then the airiness of the scenes can have quite a powerful emotional impact.

Again, by allowing lighter areas to blow out, you are inviting critiques from people who will see the images as simple mistakes. But if you were to scan the calendar and greeting card racks you would see that this is actually a very popular technique in establishing a bright, cheerful, and upbeat mood in photos. In other words, art directors often see this as a welcome technique for creating a clean, positive representation of a given subject.

One interesting byproduct of giving extra exposure is that colors tend to shift toward a more pastel range that further increases the welcoming mood of such images. While this is a delicate craft, as almost all hues weaken with increasing brightness, the eye will pay correspondingly more attention to subtle nuances of tone and contrast—and these subtleties are very much where high-key photography thrives.

← **Not quite clipped**
Illuminated by a studio flash aimed directly toward the camera from behind a sheet of Plexiglas, these orchids are bright, but not blown out (or "clipped"), and you can clearly follow the distinct lines around the edges of each petal, tracing the overall shape of the flowers.

← **Definitely clipped**
Here, the exposure was increased by just one stop, but the difference is dramatic. The petals appear translucent, with a shift toward brighter pastels. Indeed, this high-key shot sacrifices shape in order to stress color and light.

The more that you increase exposure, however, remember that you are also tossing aside things like surface and edge detail as well as texture in the lighter regions. You are also shifting what would normally be the darker areas into a range of middle tones or even above-middle tones. Accordingly, the high-key technique is not appropriate for accurate representations of subjects with significant detail in shadow areas. Also, if your subjects are backlit (daffodils backlit by a low-raking sun, for instance), you will also begin to lose shape as the edges are eroded by backlighting. If you push this effect far enough, you can obliterate large mounts of edge detail, and have your subject appear to be floating in mid-air, bursting forth out of the clouds.

Hug the Highlights with a High-Key Shot

↓ Show off the subject
The challenge of adequately lighting a close-up shot is often remedied by simply going overboard and bathing the subject in a soft, enveloping light for a high-key interpretation.

With their cheerful tones and luminescent glow, it's no wonder that high-key images are the staple of the greeting card and calendar industries: How can you turn away from pictures that beckon you with their brightness? That is the charm of photos that are created from a wash of bright tonalities spun together with joyful abandon and an aura of purity is the glue that holds them together.

One of the keys to mastering this challenge will be your ability to see or create compositions that are dominated almost entirely by tones that are lighter than middle gray. And one way of exaggerating their glow is to abandon detail in some of the brightest ranges—intentionally abandoning detail and texture in favor of establishing an upbeat and innocent mood.

→ Soft contours

High-key interpretations invite the viewer to appreciate what little textural details remain, and so a subtly overexposed approach can often be more effective than a proper exposure.

Challenge Checklist

→ If you're thinking of setting up a high-key still life, picture yourself in a market picking props. What would you choose? Eggs? Gardenias? White pottery?

→ Don't panic when the highlights begin to run off the right edge of your histogram with high-key images—remember that you're allowing some detail to escape in favor of setting a mood.

→ Shooting a portrait? Use a white bed sheet as your backdrop and second one as a wrap for your model. Just be sure to use plus compensation from whatever you meter to push the tonal range up several zones.

© Richard Gottardo

This shot was taken on an extremely bright sunny day. Exposure was taken on the models face while blowing out the background and using a 42-inch white reflector to fill in the harsh shadows from the mid day sun.
Richard Gottardo

Excellent. The big reflector (the eyeballs tell us how large it is) helps to give the image the look of a controlled studio shot, combined of course with the high-key exposure which typically has the effect of cleaning up and simplifying everything tonally.
Michael Freeman

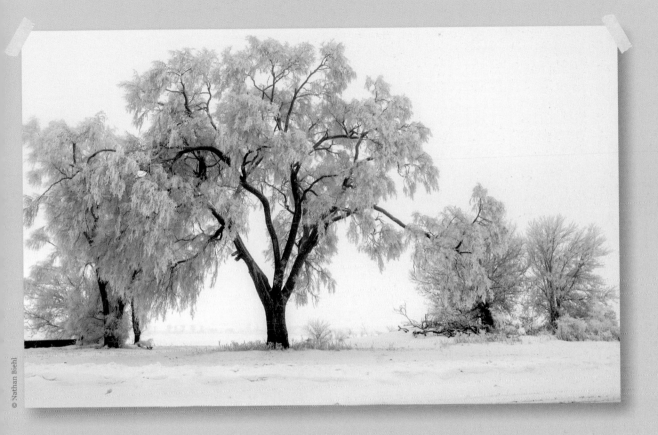

© Nathan Biehl

Referencing the histogram, I was able to the retain details in the frost and snow while keeping the overall brightness of the scene intact. f9 at 1/250 second, ISO 200 with -1EV exposure compensation.
Nathan Biehl

An attractive white-on-white situation to begin with, and you've maintained the delicacy that's important. It would be interesting to know how far you could push that delicacy by increasing the exposure, in order to make the frost-laden branches even more ethereal.
Michael Freeman

Dark Subject, Light Background

As we have already discussed, all in-camera and handheld meters are designed to operate on the premise that everything that you're metering produces an average amount of reflectance or, in photographic terms, about 18-percent reflectance. This concept, however, would mean that for every exposure reading to be completely accurate without any intervention from you, we would need to live in a world where everything, regardless of color had the exact same single tonality. Not only would this be an intensely boring world visually, but it would probably spell the end of photography as a hobby.

Fortunately for our imaginations and visual pleasure, the world is made up of a vast range of tonalities. But in order to record these many tones on a sensor that has a limited dynamic range, it's often necessary to make difficult decisions when it comes metering and setting exposure.

↓ The eyes tell it all

This is an extremely challenging exposure scenario—with a jet-black subject in shadowed foreground in front of an area receiving direct midday sun. Just enough shadow detail is kept to see the puma's eyes and whiskers, but most of the body is allowed to fall into pure black.

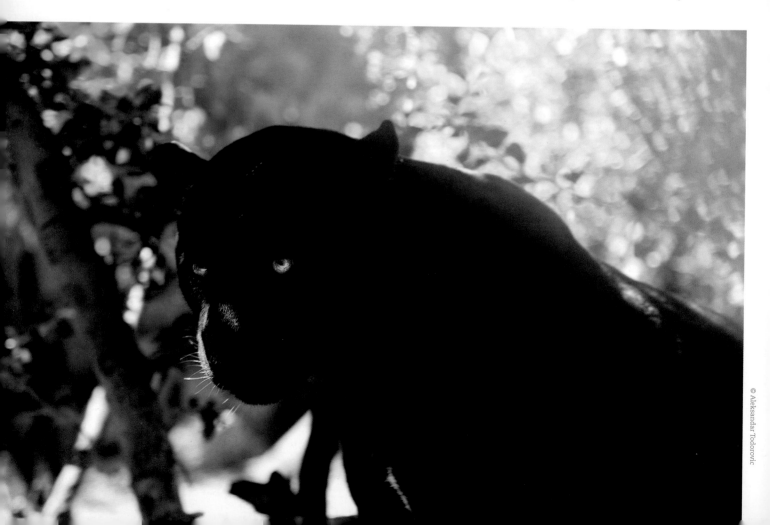

Capturing detail in a dark subject set against a lighter background presents a challenge of balancing exposure: You want to record detail in the darker areas but don't want to lose detail in the lighter tones. Suppose you are photographing a black bull standing against a white barn, for example, and you read just the bull and get a reading of 1/250 at f8. If you set your camera to this reading you will get a bull that is closer to middle gray than black. In order to darken the bull, you would need to reduce the exposure—probably by a full stop or more. By setting the exposure at 1/250 second at f16, for instance, you have reduced exposure for the dark subject by a full two stops which is probably enough to render that subject as black but with some surface detail (Zone III). If you underexpose too much, of course, you begin to lose important surface texture and detail.

In terms of the bright background, however, as you reduce exposure for the bull you will simultaneously bring down the brighter values in the barn wall. If the contrast is not too extreme this may enable you to get the darker tonality that you want in your main subject while also maintaining detail in the lighter background areas. It's definitely a bit of a tightrope walk in many situations.

If the dynamic range between the bull and the wall is too extreme, of course, you still may not be able to reduce he exposure sufficiently to hold detail in the white background. If detail in that area is crucial to your photo, then it is probably worth underexposing the darker areas in-camera and then opening them up during editing. Alternately, of course, you could use

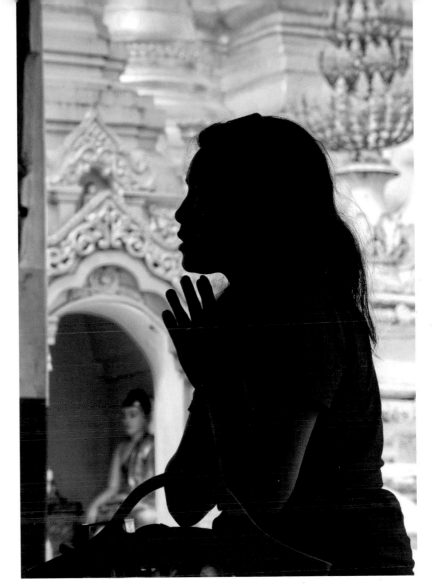

a reflector or flash to raise up the exposure of the darker areas—provided that doing so didn't destroy the richness of the darker tones.

Again, it's far easier to brighten a dark area in editing and rescue some detail there than to try and recoup highlight detail, while staying aware of the risk of enhancing noise in the boosted shadow areas. As a general rule in digital photography, the highlights are to be preserved at (almost) all cost, because if something is lost to pure white, there will be no detail at all to recover, no

↑ When foreground is more important
In order to preserve the peaceful, meditative expression on this subject's face (and avoid rendering her as a complete silhouette), a balance had to be struck between her shadowed figure and the bright tones of the background.

matter how much editing you do. In metering either type of scene—dark against light or light against dark—it's vitally important that you use a selective meter reading so that you are sure that the background is not influencing the reading from your main subject.

Light Subject, Dark Background

Probably one of the toughest contrast situations with which you'll have to contend is photographing a very light subject against a very dark background: a bride in a snow-white gown against a shadowed wall, for example, or a swan against inky black water. The key thing in such a shot is almost always to hold detail in the brighter area. In the case of the wedding gown or the swan, you want to capture just enough detail to reveal hints of surface texture without shifting the white to a light-gray value (i.e., Zone VII). The rule here is straightforward: Expose for the highlights and surrender the shadows.

Compared to the value of capturing detail in the highlights, the background is relatively insignificant—the key thing is to selectively meter from the white. If there happens to be detail worth holding in the shadow regions, your best bet is to save that in editing. But if you give too much exposure to the highlight areas and lose detail there, there is no way to reclaim it. Once highlight details are washed out, they are gone forever—you cannot fabricate details in highlight if they were not recorded in the initial exposure.

The key consideration here is twofold: holding detail in the brighter areas and not giving it so little exposure that it records as a light shade of gray. Your bride wants to be married in a cloak of white, and will expect as much in your photos. What you are after is white with some degree of surface texture. Since you know that the meter is going to provide a reading that will record that white as middle gray, you must add some exposure to that reading to lighten it back to white. The trick is to meter the white area and then, using your exposure compensation, keep adding exposure until you just begin to lose detail in the brightest areas.

← Frame bright subjects with drop-out black
Not only are the white cloaks worn by the central figures much brighter than the background, but some of the figures are in direct sunlight, some partially shadowed, and some in full shadow. Obviously a balance has to be struck, and in such a scenario, the unimportant background is the first thing to drop—jettisoned off the far left of the histogram.

Because it's usually difficult to make such judgments using just your LCD display, you're much better off keeping an eye on your histogram display to be sure there are no bars bunching up at the right side of the graph. A very useful tool in such situations is your Clipping Warning—a feature that can be activated in Playback on your LCD that makes parts of the frame that have blown out to pure white flash in a noticeable color (usually red). This tells you not only the fact that highlights are being lost (which the histogram also does), but also where exactly in the frame that lost detail belongs. You can then take a new measurement, or apply some negative exposure compensation as needed. Again, this exposure will probably cast the darker shadow areas into blackness, but black is black so this typically is not a concern. And if the black is not dark enough, you can always render it a darker tone using the curves control in editing.

You can use this same philosophy when it comes to broader scenes, such as landscapes, that contain an exceptionally wide range of tones. If, for example, you're photographing a white church set against a dark hillside, the church is the more important consideration. By exposing correctly for the building you are likely abandoning the detail in the surrounding landscape, but it's a necessary forfeit. The alternative is a church building void of detail and an exposure that looks like a mistake.

Incidentally, you could also take the reverse course to the same destination and meter the dark areas and then subtract exposure until you brought the light tones into range but it's probably a somewhat back-door approach.

© Vladislav Lebedinski

↑ Left to right, bright to dark
Even if the background is definitely darker, it may be unevenly lit itself, giving you the opportunity to capture a subtle gradient as it slides off from mid-tone into pure shadow.

Contrast your Subject against a Background

↓ High horizon, busy scene
A high horizon line is often impossible to avoid clipping when the main subject is in the shadowed foreground. But the reflections and resulting flare add to the atmosphere of the scene.

While extremes of contrast are a constant battle for all photographers, they can also be a source of great drama. The key is learning how to harness contrast in a visually effective way. One method is to contrast a subject, either in color or tone (or both) against a background of conflicting color or brightness— a swan gliding across a dark pond is the classic example.

You probably see contrast situations every day that would make dramatic images. And for this challenge you'll scout out such scenes and isolate them from their surroundings. The trick will be to expose the scene so that both background and foreground are acceptably rendered. Will you need to sacrifice detail or color fidelity in one area or the other? Perhaps—figuring that out is part of the challenge.

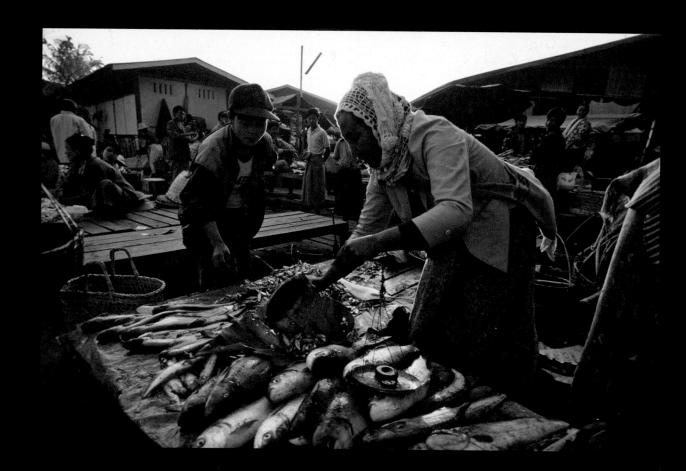

→ Dark studio backdrops

Though high-contrast situations are often discussed in terms of how to tame them when they are encountered in the field, they are nevertheless frequently created intentionally in the studio as well. The reflective surface of this jewelled cigarette case is brought all the more to life by being contrasted against a dark, rich velvet backdrop.

Challenge Checklist

→ If your primary subject is surrounded by an excessively bright or dark background, switch to center-weighted metering to isolate the most important areas.

→ Unless the area that you meter is a middle tone, use exposure compensation to place it where you want it on the tonal scale.

→ Black backgrounds are less of an issue since you aren't seeking any detail there anyway—so go ahead and expose correctly for the highlight and let the dark areas fall where they fall.

Review

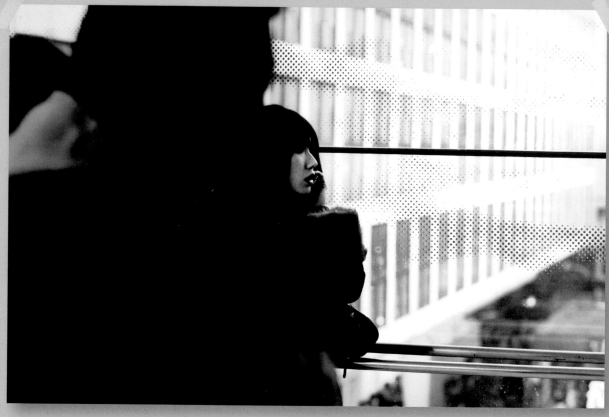

I set the EV to -1/3, which helps me to avoid overexposed highlights. However, the shot was taken on the spur of the moment to capture the woman's expression, without much thought to the exposure. The high-key contrast was strengthened with post-processing. f4 at 1/250 second, ISO 1600.
Lukasz Kazimierz Palka

You've held the two key elements—the woman's face and the bright exterior. Also good is the woman's separation from the exterior by the edge of her hair and her hand. I wish the shot was taken a split second earlier, so the foreground would have been separated, but in these situations you get what you get.
Michael Freeman

© Nick Depree

Museum Plantin-Moretus, Antwerp. I exposed to get sharp detail in the printing of the Gutenberg Bible, and the white pages as I saw in real life, letting the background go completely black to hide detail or shadows in the lining material of the display case. f3.8 at 1/50 second, ISO 1600.

Nick Depree

Black, as you've discovered, can be a very convenient default background, because it conceals everything. From the appearance alone, this could well have been a studio shot with you in full control of the object and setting.

Michael Freeman

Photographing by Existing Light

While almost everything that we've discussed so far is aimed at taking pictures in daylight situations, some of the most interesting photo ops and demanding exposure scenarios are far removed from the luxury of the sun's brilliant light. Hidden indoors away from the abundant direct illumination of the sun or tucked away in the secret corners of the night is a world rife with colorful photographic possibilities.

Getting the most from the creative challenges posed by existing-light and outdoor night photography is a lot simpler than you might imagine. All that you'll really need are a good tripod and an adventurous spirit—and perhaps an interested companion to wander with you into the night.

Indoors by Existing Light

Getting acceptable exposures of interior spaces presents a series of technical hurdles that can seem daunting at first, but are easier to solve if you break them down into smaller more manageable bits and resolve each one individually. To some degree the issues you'll face depend on the type of image that you're trying to capture. A room scene shot entirely by window light, for example, is a far simpler challenge than photographing, say, a dimly lit cathedral that is lit by a mixture of daylight, artificial lighting, and candles. Overall, however, the problems that you'll face are common to most indoor setting to one degree or another and they include:

Low illumination

Depending on the type of space that you're photographing, the illumination can range from almost non-existent in the dungeon-like darkness of a subterranean pub, for example, to a more brightly illuminated hotel lobby or a modern office suite. Most dim light levels can be solved either by raising the ISO or using long exposures and a good steady tripod. And though some interior spaces—particularly huge ones like cathedral interiors—might seem gloomy beyond all hope, with the extreme range of ISO speeds available, there are few subjects so dimly lit that you can't get an acceptable exposure.

The primary exposure question you'll face in any dimly lit interior space is whether you should raise the ISO setting or use a lower setting and set longer exposures. Since in most situations you won't be trying to stop action or concerned with motion, you're usually better off keeping the ISO at a moderate to low setting to reduce image noise. That said, however, even at low ISO speeds you can also get excessive image noise by using longer exposure times. Many cameras (particularly high-end DSLR bodies) have long-exposure noise reduction, so read your manual to see if your camera offers a way of improving this problem.

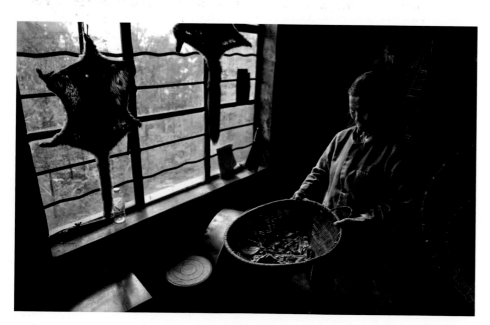

← Side-lit window scenes
By framing only the interior area that was lit by the outdoor light, the other light sources at the far end of the room were of no concern.

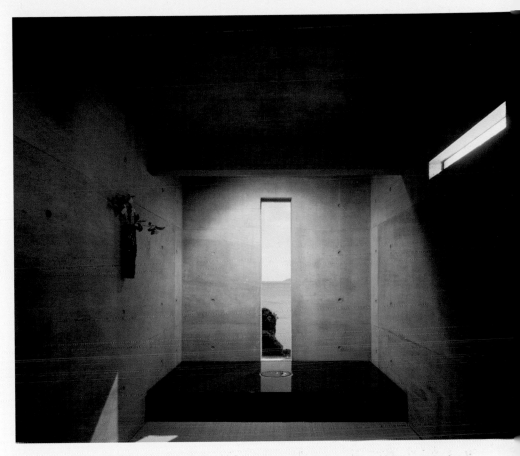

→ **Make color casts work**
A daylight white balance keeps the view outside looking natural, and the concealed tungsten light at the far end of this room gives a yellow cast that complements the deep red surface along the floor.

Mixed lighting sources

A far more vexing problem than mere low illumination is trying to find a way to come to terms with a variety of extremely different and mixed light sources. Almost every interior space that you walk into is lit by as many as a half dozen or more separate light sources, each producing its own color and intensity of light. Think about a small café in late afternoon, for example, you probably have some source (and usually more than one) of tungsten illumination as the primary source, some daylight spilling in from windows, perhaps a few fluorescent lights spilling in from the kitchen, a neon sign or two over the bar area, and candles on the tables.

Trying to find a white balance setting that will create a unified look to these sources is utterly hopeless, but then, nor is it usually necessary. The better solution is to choose the source that you think is most dominant and most attractive in terms of overall lighting, and set your white balance for it. If, for example, the bulk of the dining area is lit by tungsten lamps, then coolness of some daylight or the added warmth of the occasional spotlighted area or candle-lit tables will add a realistic touch of ambience to the room.

Degrees of daylight

Much of how you balance the lighting color of a room will depend on whether or not daylight is a prominent (or primary) source of light indoors. Older spaces tend to have fewer windows and so daylight is less of a problem (or a solution, depending on your point of view), while modern spaces tend to be dominated by daylight—sometimes exclusively so. Where daylight is a primary source, color balance is less of an issue, though contrast may be greatly increased.

Contrast issues

Contrast is a particularly difficult issue in some interior spaces because often areas of very bright illumination—a restaurant table lit by an overhead lamp, for instance—are surrounded by deeply shadowed areas. Similar contrast situations occur any time that you have rays of bright daylight entering into large, dark spaces. The best solution here is to expose for the brighter highlight areas and then "open" the shadows during editing. If a tripod is allowed, a far better solution may be to use HDRI (see pages 106–107) and create a series of exposures, each of which addresses a particular area of brightness.

In all contrasty situations, it's best if you take your meter readings from a neutral-color surface that is close to middle-toned—a brick wall or slate mantle, for example. The ultimate metering solution is usually to use an incident light meter, or a gray card with the camera's reflected-light metering, so that the reflective nature of the surfaces themselves are removed from the equation.

Expose for a Dimly Lit Interior Space

↓ A light in the dark
While easy enough to meter, this tunnel required quite a long shutter speed (and a tripod) in order to capture any detail along the wall surfaces. In reality, the light at the end of the tunnel was quite dim.

It's so tempting when we walk into a dimly lit room to pop on the flash and illuminate the darkness. But doing so tends to kill the romance of the moment. Though the wine cellar of a French vineyard may not have much to offer in terms of illumination, it may have much to offer when it comes to atmosphere. Architectural interior photographers, in fact, go to great lengths to either preserve or recreate the ambience of such spaces.

To successfully complete this challenge then it's up to you put your metering skills (and your tripod) to work to find a way to record the look and feel of a dimly lit space, sans any additional lighting. Contrast will likely be an issue to deal with, as will the color temperature of artificial lighting. The real challenge here is to capture the charm of the scene as it appears to the naked eye.

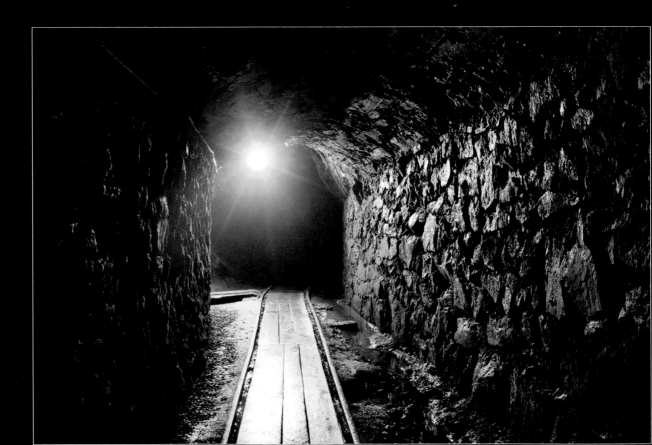

→ **Bright desk, dark floor**

Photographing indoors often requires you to make the tough decisions as to where you want to allow your shadows to completely block up and lose detail. Perfectly even, diffuse light is rare in such spaces—but that is precisely what gives them such character.

Challenge Checklist

→ Often dimly lit interior spaces are lit by a mixture of lighting sources—daylight from a window and overhead lamps, for instance. Run white balances tests or shoot in Raw to deal with this issue.

→ Avoid including any light sources in the frame when metering—a neon sign over a bar, for instance, will cause the meter to underexpose darker areas.

→ No tripod? Set your camera on a tabletop or the back of a pew in a church and use the self-timer to fire the shot.

→ If contrast is an issue, consider a multi-shot technique like high-dynamic range imaging so that you can take separate exposures for bright and dim areas—in a cathedral interior, for instance.

© Dmitry Naumov

Review

© Nathan Biehl

Due to the museum's restriction on tripods, a stone railing was required to support the camera during this slow exposure. f3.5 at 1/15 second, ISO 200.
Nathan Biehl

You managed the exposure perfectly, although the camera placement lets the shot down. There's a distinct feeling of wanting to look over the parapet, and the out-of-focus close foreground does spoil it. I appreciate caution in these matters, but could you not have (carefully) placed the camera closer to the edge?
Michael Freeman

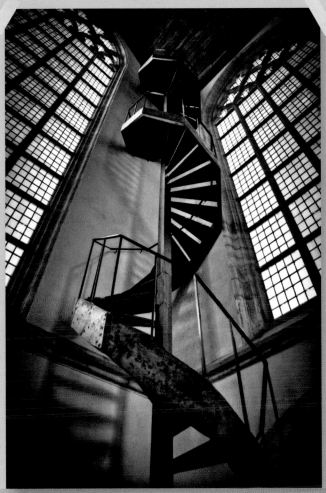

© Nick Depree

Oude Kerk, Amsterdam. While the windows light the church interior, the staircases in the corners are dark and required careful metering and a steady hand to reveal the detail. f3.5 at 1/125 second, ISO 1600.
Nick Depree

Exposure correct, holding the highlights and preserving the natural atmosphere. Tripods are often not allowed in interiors, and we don't always want to carry one around anyway, so handheld was the way to go. At ISO 1600 there will be limits to how large you can reproduce this image—that's just the price to pay.
Michael Freeman

Exterior Night Shots

City Skylines

There's nothing quite like the sight of a city skyline glimmering in the distance—certainly nothing found in nature, anyway. The toughest part is often simply finding a vantage point that lets you fill the frame with the skyline and where the intensity isn't diluted by other nightlights. Often the best places for shooting are from bridges that overlook the city, or from the high roof of another building (a parking garage, perhaps—something that allows you open access to the upper floors).

Although we tend to imagine most city skylines as being "night" subjects, in fact, the best time to photograph them is closer to sunset or twilight—just after the sun has set and the city lights are starting to shine. Remember, most city buildings have their interior lights

on well before full night-time, and so you normally don't have to wait for them—they will begin to shine brightly right at dusk. If the buildings are also spotlighted, of course, those lights may not come on until nightfall.

When the sun is close to the horizon, you're confronted with a spectacular set of lighting conditions. For one, if there is still light in the sky, you substantially moderate the contrast because the building facades are still being illuminated. Once the sky has gone completely dark, all that you are left with is the contrast between the bright window lights and the dark sky.

On the other hand, if you shoot when there is still some blue in the sky, you provide a rich and vivid backdrop that is more colorful than a black sky. Interestingly, during the period of time about 30–50 minutes after sunset when

the sky is a rich sapphire blue, you can get a good meter reading for skyline scenes by reading the sky itself. At this time of day, both sky and buildings will be illuminated by approximately the same amount of light.

And again, if you shoot in the Raw format, you can not only adjust the exposure of the skyline and lights themselves, but you can adjust the white balance to strike a harmony between the light on the front of the buildings and the blue in the sky.

It's often quite amazing just how radically a spotlight can transform an otherwise average building into a work of near theatrical drama. Even the local library or bank can take on an entirely different persona after dark, and in some cities, like Budapest, lighting city views has been elevated to a fine art.

One of the problems in photographing such scenes, however, is that they are typically lit by either sodium- or mercury-vapor lamps (both types of gas-discharge lamps), and the color of these lights tends to saturate the entire scene. What this means is that you're often capturing the color of the light as it reflects off of the building surfaces rather than the true colors of the buildings (stone, concrete, steel, etc.) themselves.

© Wong Sze Fei

← **Streaking out distractions**
A bonus of shooting long-exposure cityscapes is that (so long as a proper tripod is used) any motor traffic will blur into long, elegant streaks that further emphasize the streets and paths throughout the frame.

themselves. Further, the actual color of the light depends entirely on its source: sodium vapor lamps tend to record in the yellow/orange range while mercury vapor lamps are more blue/green. It is rarely possible to entirely correct or neutralize the color of vapor lamps using your white balance control, so it's almost not worth the attempt. Besides, often the color casts created by such lights are interesting and dramatic and eliminating them takes away some of the theatrical excitement.

A larger issue, of course, is that while these scenes look relatively bright to your eye, the truth is that it's often a comparative brightness: You're seeing the spotlighting against a backdrop of black. Exposures tend to be anywhere from a few seconds to many seconds and the smaller the aperture that you're using, of course, the longer the exposure will be. Since you often want to capture as much depth of field as possible, that means that you'll be using small apertures and rather long exposures. A tripod is mandatory for such scenes, and it's also a good idea to use either a remote trigger or at least the self-timer to fire the camera in order to avoid creating any vibration. On a DSLR, locking the mirror up is a wise precaution, as mirror-slap is a cause of camera shake.

Metering is best done using a neutral surface such as a brick or slate wall since these are close to a mid-tone. You have to be very careful not to include any bright light sources facing the camera when you take your meter readings since this will result in a gross underexposure of the overall scene. Often you can eliminate such lights from the frame by simply taking a few steps to the left or right and hiding the light sources behind a piece of the façade, or some foreground object.

← A glow around the edges
A stop of negative exposure compensation would have rendered the blacks of this image even more dominant, and added boldness and saturation to the reds and blues in the neon sign itself. However, by allowing in a bit more light, this exposure captures the soft glow emanating around the hard edges of the sign, which adds to the overall effect. You typically have a fair amount of wiggle room in regards to the exposure with neon lights, so experiment and see what works for you.

Neon Signs

Exposing neon signs is relatively easy and they offer a surprising amount of latitude. You can often get a good shot of neon with a wide variety of exposures and the only thing that will really change is the intensity of the colors (and often that can be substantially altered or enhanced in editing—particularly if you shoot in the Raw format).

Most neon signs are bright enough for a handheld shot at ISO 100 or 200, and the closer you are to the light, the more intense it will be. Matrix metering generally handles neon quite well, but be aware that it's far better to underexpose by at least a stop, both to saturate the colors and let peripheral distracts fall into shadow. If you're photographing a neon sign in a store window, it's also a good idea to wait until the store is closed and the interior lights are turned off, because if there are inside lights on, it's difficult to get a black background for the sign. In editing you can tone down backgrounds by increasing the black levels and/or pulling down the shadows.

Design-wise, in addition to taking one overall shot of a sign, look for interesting abstracts created by closing in on small bits of a sign or skewing the camera somewhat to more extreme angles.

Capture the Light from a City at Night

↓ Blues and oranges
The rich blues in the sky that can be captured just as the light starts to fade are a natural complement to the artificial sodium-vapor lights so typical to city street scenes.

Whatever mood a city projects by day, whether it's the rattle and hum of the commercial world or the stillness of a concrete desert on a hot August day, by night the city is a festival of light and color. Stand back at a distance and look at any city at night and this is not so much a challenge as a celebration of illumination and color and shape. Under the cloak of darkness only the

Oz-like beauty of a city shines through and from the right vantage point finding great ideas for skyline shots is almost like shooting fish in a neon barrel—it's that easy. But whatever ease the city offers in terms of design possibilities, it will still challenge you technically. Long exposures, smoggy skies and image noise are among the demons you'll have to wrestle.

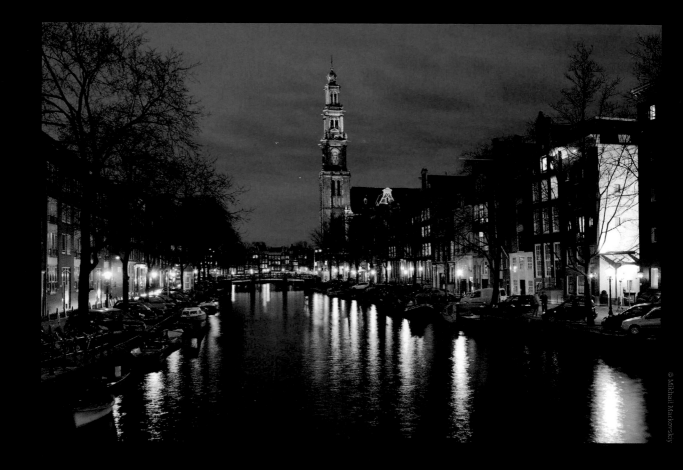

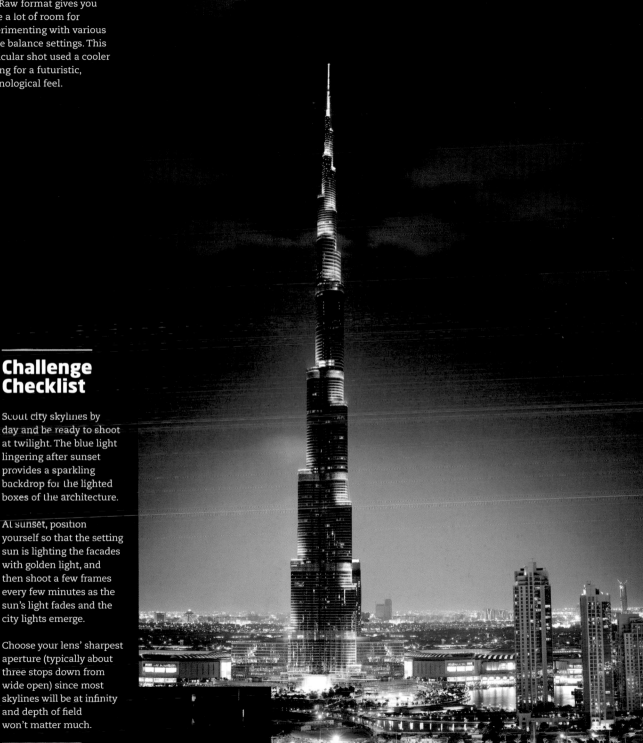

→ Dubai skyline

Shooting twilight cityscapes in a Raw format gives you quite a lot of room for experimenting with various white balance settings. This particular shot used a cooler setting for a futuristic, technological feel.

Challenge Checklist

› Scout city skylines by day and be ready to shoot at twilight. The blue light lingering after sunset provides a sparkling backdrop for the lighted boxes of the architecture.

› At sunset, position yourself so that the setting sun is lighting the facades with golden light, and then shoot a few frames every few minutes as the sun's light fades and the city lights emerge.

→ Choose your lens' sharpest aperture (typically about three stops down from wide open) since most skylines will be at infinity and depth of field won't matter much.

Review

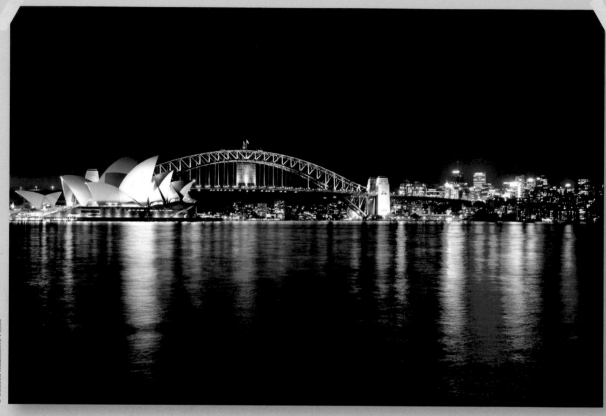

© Lukasz Kazimierz Palka

In this shot, I manually set the camera to f4, ISO 200, and +2/3EV which forced to camera to select a 10-second exposure. I also set the color temperature to 2500K, which gave the image a blue cast and then I recovered some of the other colors and reined in the blues with post-production.

Lukasz Kazimierz Palka

Going for the color is a clear decision here, and the advantage of doing this is that you've deepened the picture area, as it has allowed the reflections in the water to become a significant part of the image. This makes a refreshing change from the majority of images that include Sydney Opera House, where it usually dominates.

Michael Freeman

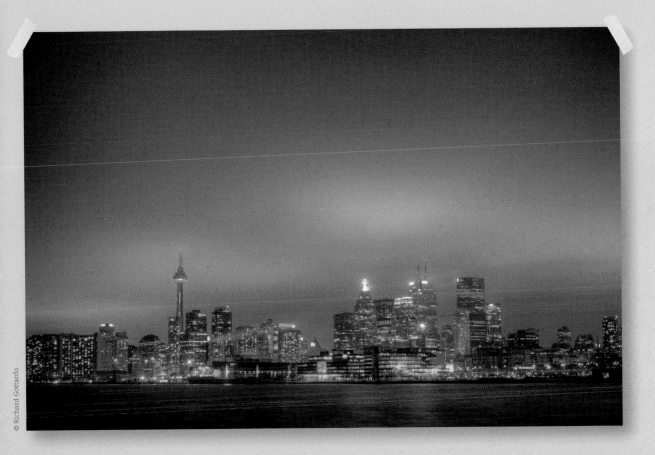

© Richard Gottardo

This shot was taken with a 30-second exposure using a tripod in order to capture the movement of the fog above the city. A very narrow aperture of f10 was used in order to facilitate using such a long exposure. ISO 125.
Richard Gottardo

An interesting mood change from the picture opposite, demonstrating that there's always more than one way to tackle a similar subject. There's a soft, slightly unreal atmosphere from the drifting fog that adds a noticeable overlaid blurring.
Michael Freeman

The Ultimate Contrast Solution: Silhouettes

When it comes to certain extreme high-contrast situations, the old adage "If you can't beat them, join them," is not bad advice. Consider exploiting an extremely contrasty subject by turning it into a silhouette, which by definition has no detail within its outline. Silhouettes are a great way to solve exposure problems when the contrast is simply off the scale with respect to a camera sensor's dynamic range. Rather than trying to set a mediocre balance between the background and foreground, you can sacrifice surface detail in favor of graphic shapes with bold edges.

Silhouettes are easy to create: Any time that you have a particularly dark subject that is surrounded by a bright background you can convert it to a silhouette simply be exposing for the background. If the contrast is extreme enough, you'll end up with a black shape in front of a very bright but correctly exposed background. The subject does need to be sufficiently opaque so that its shape remains bold and intact against such a bright background.

Silhouettes are at their best with subjects that have very defined and quickly identifiable shapes. Subjects like a lone tree on a hill, a fisherman on the shore against a sunrise sky, or a sailboat gliding through a colorful sunset are prime examples of subjects with excellent silhouette potential. Even relatively intricate subjects can be potentially good subjects if carefully isolated: a resting dragonfly against the circle of the sun or a spider in its web in shade contrasted against a brightly illuminated green lawn. And even if you don't stumble across a potential silhouette composition naturally, you can often introduce one by placing an interesting shape in front of a bright, colorful background—a friend on a bicycle against a bright sandy beach, for instance.

Done well, silhouettes are elevated into a distinct artistic genre. Though no longer as popular as they once were, paper-cutting artists were once very popular in the art world. Talented silhouette artist were so skilled, in fact, that they are able to imbue even the simplest profile outline of a human face with a sense or personality. And some faces in silhouette have become almost more iconic and recognizable than their fully lit counterparts—Alfred Hitchcock being a case in point. Silhouettes need not be motionless or stagnant subjects, either. A pole-vaulter

© Beltsazar

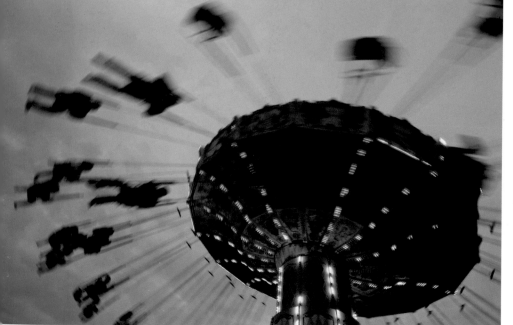

← Varying exposure levels
A silhouette can be the dominant subject of an image, or just another compositional element. Here, the motion-blurred silhouettes add a dynamism to the carnival ride.

→ Shimmering silhouettes
Strong reflections, like those in the surface of this river, would usually be something to fight against, but if you surrender the exposure to them, they create a lively silhouette.

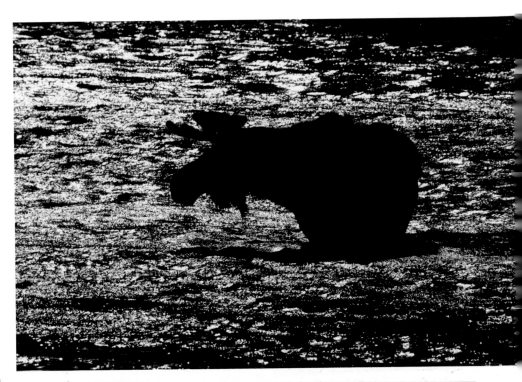

silhouetted against a blue sky combines action and graphic drama that likely wouldn't be improved or any more exciting if it was frontally lit. It's important when you are photographing an entire human figure, however, that the arms and legs are spaced from the torso in some interesting way so that they don't just meld into an awkward blob-like body shape.

Set Exposure Carefully for Silhouettes

Though the concept of exposing for a silhouette is simple enough, small adjustments in exposure can often make a large difference. For the subject to really pop, for instance, the subject needs to be completely devoid of surface detail—the exposure must be set so that your subject is recorded as pure black. Often it's best to meter the bright area exclusively and to leave your subject out of the frame during metering.

You are not necessarily restricted to a purely silhouetted subject, of course, and if the situation allows you can often bracket exposures and made your decision after. Also, you can almost always correct slight overexposure in the subject area by merely setting your subject as the black point during editing. Indeed, with this in mind, you can concentrate on capturing the ideal tones in the background, even if that means your original, out-of-camera shot isn't a perfect silhouette.

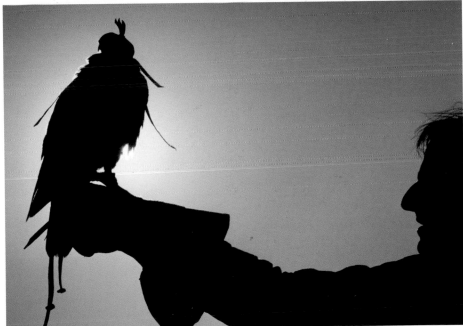

↑ The sensor cannot see the falcon
If the background isn't uniformly bright enough to render a silhouette, try positioning yourself such that the subject lines up between the light source (in this case, the sun) and the camera.

Challenge

Show Off the Shapes with a Silhouette

↓ Negative detail
While a strict silhouette should have no detail at all in the surface of the subject, the edges can still show off plenty of detail by contrast, as seen with these countless tiny branches cast sharply against a golden sunset.

Whenever it comes to a showdown between a very bright background and a dark, opaque foreground, the concept of creating a silhouette is one easy way to exploit that contrast and come up with a winning shot. And to succeed at this challenge you need only remember the simple rule of creating a silhouette: Expose for the background and let the foreground fall into deep shadow.

Silhouettes are the ultimate tribute to a subject's shape and unlike many subjects, they actually benefit from the two-dimensional limitations of a photograph because they are not trying to reveal form, volume, or surface detail. They reveal only a subject's most pure outline form.

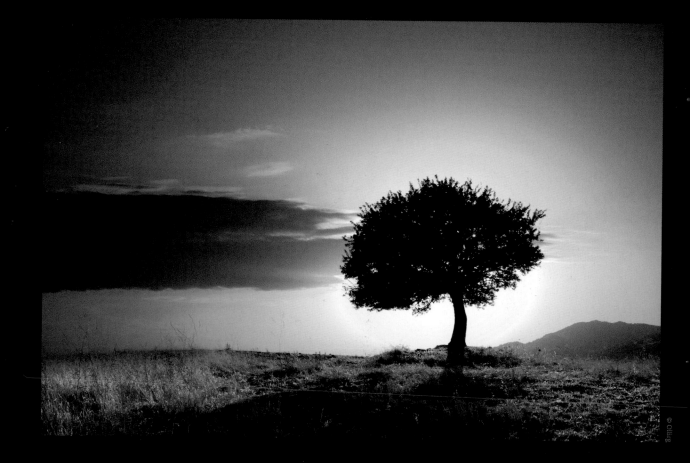

→ **Triumphant darkness**
This shot excellently
demonstrates the importance
of the shape and outline of
your silhouette subject, and
also how important it is that
the foreground be completely
devoid of detail—such
information would have only
been a distraction in this case.

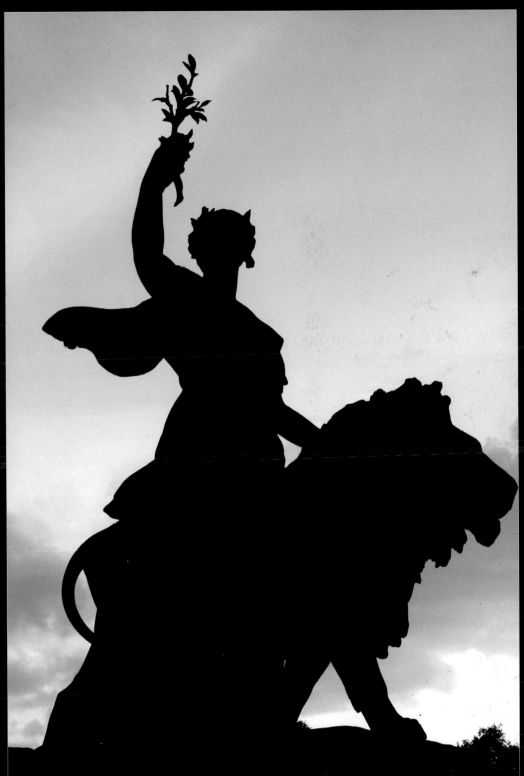

© Christopher Nolan

Challenge
Checklist

→ You'll need to employ
your exposure lock
feature to be certain your
exposure is set for the
brighter background.
But don't worry if the
foreground gets some
detail, you can always
bury it in editing.

→ Dramatic colorful
backgrounds make the
best silhouette settings:
sunset skies are a natural.
But black and white
silhouettes are equally
effective, so consider
making a monotone
conversion from your
best shot.

→ Creating silhouettes
around the house is easy,
too. Try setting a few
pears to ripen in a sunny
kitchen window and
expose for the brighter
background. Be sure
though to focus carefully
on your primary subject
and use a shallow depth
of field.

Review

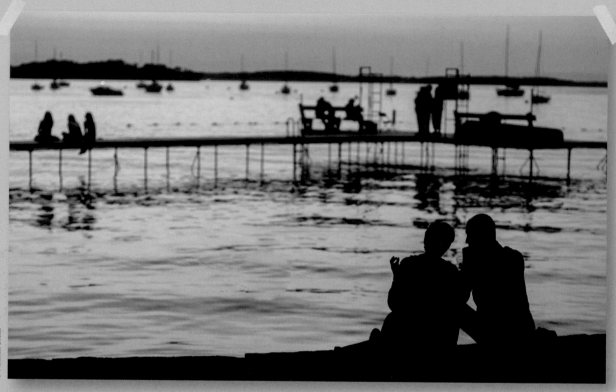

© Nathan Biehl

By exposing for the reflection of the sky in the water, I was able to preserve the colors of the sunset as it silhouetted the couple's conversation. f2 at 1/80 second, ISO 400.
Nathan Biehl

I like the suffusion of pink-magenta, which is atmospheric. Also, some thought went into the composition, in which the foreground couple relate to the three seated figures on the jetty, and this sets up a diagonal that enlivens the image. An alternative would have been to let the foreground go to pure silhouette.
Michael Freeman

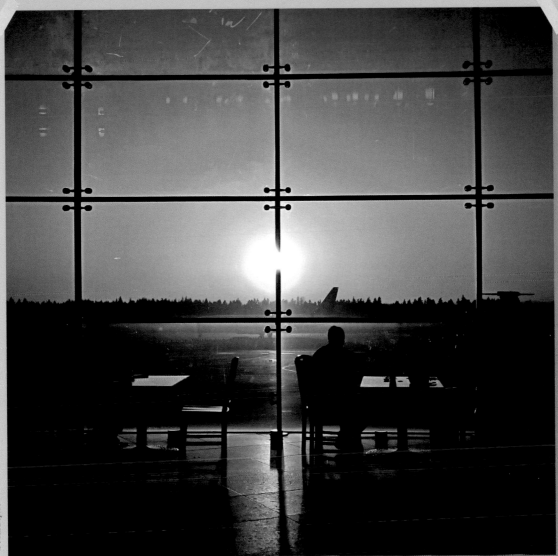

© Nick Depree

Sea-Tac Airport, Seattle. Flying out in the evening gave a great chance to capture silhouettes of other travellers sitting against the large glass wall. f2.8 at 1/800 second, ISO 80.
Nick Depree

I see you made use of one of the vertical window dividers to cut the sun and reduce its strength lightly. The carefully positioned square-on framing pays off, also. I wonder if some slight local increase in brightness and contrast might usefully help to clarify the seated figures on the left and right.
Michael Freeman

Glossary

aperture The opening behind the camera lens through which light passes on its way to the image sensor (CCD/CMOS).

backlighting The result of shooting with a light source, natural or artificial, behind the subject to create a silhouette or rim-lighting effect.

bracketing A method of ensuring a correctly exposed photograph by taking three shots; one with the supposed correct exposure, one slightly underexposed, and one slightly overexposed.

brightness The level of light intensity. One of the three dimensions of color in the HSB color system. *See also* Hue and Saturation

CCD (Charge-Coupled Device) A tiny photocell used to convert light into an electronic signal. Used in densely packed arrays, CCDs are the recording medium in most digital cameras.

channel Part of an image as stored in the computer; similar to a layer. Commonly, a color image will have a channel allocated to each primary color (e.g. RGB) and sometimes one or more for a mask or other effects.

CMOS (Complementary Metal-Oxide Semiconductor) An alternative sensor technology to the CCD, CMOS chips are used in ultra-high-resolution cameras from Canon and Kodak.

color gamut The range of color that can be produced by an output device, such as a printer, a monitor, or a film recorder.

color temperature A way of describing the color differences in light, measured in Kelvins and using a scale that ranges from dull red (1900 K), through orange, to yellow, white, and blue (10,000 K).

contrast The range of tones across an image, from bright highlights to dark shadows.

cropping The process of removing unwanted areas of an image, leaving behind the most significant elements.

depth of field The distance in front of and behind the point of focus in a photograph, in which the scene remains in acceptable sharp focus.

diffusion The scattering of light by a material, resulting in a softening of the light and of any shadows cast. Diffusion occurs in nature through mist and cloud cover, and can also be simulated using diffusion sheets and soft-boxes.

edge lighting Light that hits the subject from behind and slightly to one side, creating flare or a bright "rim lighting" effect around the edges of the subject.

file format The method of writing and storing information (such as an image) in digital form. Formats commonly used for photographs include TIFF, BMP, and JPEG.

fill flash A technique that uses the on-camera flash or an external flash in combination with natural or ambient light to reveal detail in the scene and reduce shadows.

fill light An additional light used to supplement the main light source. Fill can be provided by a separate unit or a reflector.

filter (1) A thin sheet of transparent material placed over a camera lens or light source to modify the quality or color of the light passing through.
(2) A feature in an image-editing application that alters or transforms selected pixels for some kind of visual effect.

flash meter A light meter especially designed to verify exposure in flash photography. It does this by recording values from the moment of a test flash, rather than simply measuring the "live" light level.

focal length The distance between the optical center of a lens and its point of focus when the lens is focused on infinity.

focal range The range over which a camera or lens is able to focus on a subject (for example, 0.5m to Infinity).

focus The optical state where the light rays converge on the film or CCD to produce the sharpest possible image.

frontal light Light that hits the subject from behind the camera, creating bright, high-contrast images, but with flat shadows and less relief.

f-stop The calibration of the aperture size of a photographic lens.

gradation The smooth blending of one tone or color into another, or from transparent to colored in a tint. A graduated lens filter, for instance, might be dark on one side, fading to clear on the other.

grayscale An image made up of a sequential series of 256 gray tones, covering the entire gamut between black and white.

HDRI (High Dynamic Range Imaging) A method of combining digital images taken at different exposures to draw detail from areas which would traditionally have been over or under exposed. This effect is typically achieved using a Photoshop plugin, and HDRI images can contain significantly more information than can be rendered on screen or even percieved by the human eye.

histogram A map of the distribution of tones in an image, arranged as a graph. The horizontal axis goes from the darkest tones to the lightest, while the vertical axis shows the number of pixels in that range.

HMI (Hydrargyrum Medium-arc Iodide) A lighting technology known as "daylight" since it provides light with a color temperature of around 5600 K.

HSB (Hue, Saturation, Brightness) The three dimensions of color, and the standard color model used to adjust color in many image-editing applications.

hue The pure color defined by position on the color spectrum; what is generally meant by "color" in lay terms.

incandescent lighting This strictly means light created by burning, referring to traditional filament bulbs. They are also know as hotlights, since they remain on and become very hot.

incident meter A light meter as opposed to the metering systems built into many cameras. These are used by hand to measure the light falling at a paticular place, rather than (as the camera does) the light reflected from a subject.

ISO An international standard rating for film speed, with the film getting faster as the rating increases. ISO 400 film is twice as fast as ISO 200, and will produce a correct exposure with less light and/or a shorter exposure. However, higher-speed film tends to produce more grain in the exposure, too.

JPEG (Joint Photographic Experts Group) Pronounced "jay-peg," a system for compressing images, developed as an industry standard by the International Standards Organization. Compression ratios are typically between 10:1 and 20:1, although lossy (but not necessarily noticeable to the eye).

kelvin Scientific measure of temperature based on absolute zero (simply take 273.15 from any temperature in Celsius to convert to kelvin). In photography measurements in kelvin refer to color temperature. Unlike other measures of temperature, the degrees symbol in not used.

light pipe A clear plastic material that transmits like, like a prism or optical fiber.

luminosity The brightness of a color, independent of the hue or saturation.

macro A mode offered by some lenses and cameras that enables the lens or camera to focus in extreme close-up.

megapixel A rating of resolution for a digital camera, directly related to the number of pixels forming or output by the CMOS or CCD sensor. The higher the megapixel rating, the higher the resolution of images created by the camera.

midtone The parts of an image that are approximately average in tone, falling midway between the highlights and shadows.

modelling light A small light built into studio flash units which remains on continiously. It can be used to position the flash, approximating the light that will be cast by the flash.

noise Random pattern of small spots on a digital image that are generally unwanted, caused by nonimage-forming electrical signals.

pixel (PICture ELement) The smallest units of a digital image, pixels are the square screen dots that make up a bitmapped picture. Each pixel carries a specific tone and color.

plug-in In image-editing, software produced by a third party and intended to supplement a program's features or performance.

ppi (pixels-per-inch) A measure of resolution for a bitmapped image.

Raw files A digital image format, known sometimes as the "digital negative," which preserves higher levels of color depth than traditional 8 bits per channel images. The image can then be adjusted in software— potentially by three stops—without loss of quality. The file also stores camera data including meter readings, aperture settings, and more. In fact each camera model creates its own kind of Raw file, though leading models are supported by software like Adobe Photoshop.

reflector An object or material used to bounce light onto the subject, often softening and dispersing the light for a more attractive result.

resolution The level of detail in a digital image, measured in pixels (e.g. 1,024 by 768 pixels), or dots-per-inch (in a half-tone image only, e.g. 1200 dpi).

RGB (Red, Green, Blue) The primary colors of the additive model, used in monitors and image-editing programs.

rim-lighting Light from the side and behind a subject which falls on the edge (hence rim) of the subject.

ring-flash A lighting device with a hole in the center so that the lens can be placed through it, resulting in shadow-free images.

saturation The purity of a color, going from the lightest tint to the deepest, most saturated tone.

shutter The device inside a conventional camera that controls the length of time during which the film is exposed to light. Many digital cameras don't have a shutter, but the term is still used as shorthand to describe the electronic mechanism that controls the length of exposure for the CCD.

shutter speed The time the shutter (or electronic switch) leaves the CCD or film open to light during an exposure.

SLR (Single Lens Reflex) A camera that transmits the same image via a mirror to the film and viewfinder, ensuring that you get exactly what you see in terms of focus and composition.

spot meter A specialized light meter, or function of the camera light meter, that takes an exposure reading for a precise area of a scene.

telephoto A photographic lens with a long focal length that enables distant objects to be enlarged. The drawbacks include a limited depth of field and angle of view.

top lighting Lighting from above, useful in product photography since it removes reflections.

TTL (Through The Lens) Describes metering systems that use the light passing through the lens to evaluate exposure details.

tungsten A metalic element, used as the fillament for lightbulbs, hence tungsten lighting.

vapor discharge light A lighting technology common in stores and street lighting. It tends to produce color casts, especially the orange sodium vapor lights.

white balance A digital camera control used to balance exposure and color settings for artificial lighting types.

window light A softbox, typically rectangular and suitably diffused.

Index

Bibliography & Useful Addresses

Books

The Complete Guide to Light and Lighting in Digital Photography
Michael Freeman

The Photoshop Pro Photography Handbook
Chris Weston

Perfect Exposure
Michael Freeman

Mastering High Dynamic Range Photography
Michael Freeman

Pro Photographer's D-SLR Handbook
Michael Freeman

The Complete Guide to Black & White Digital Photography
Michael Freeman

The Complete Guide to Night & Lowlight Photography
Michael Freeman

The Art of Printing Photos on Your Epson Printer
Michael Freeman & John Beardsworth

Digital Photographer's Guide to Adobe Photoshop Lightroom
John Beardsworth

The Photographer's Eye
Michael Freeman

The Photographer's Mind
Michael Freeman

Websites

Note that website addresses may often change, and sites appear and disappear with alarming regularity. Use a search engine to help find new arrivals.

Photoshop sites
Absolute Cross Tutorials
www.absolutecross.com

Laurie McCanna's Photoshop Tips
www.mccannas.com

Planet Photoshop
www.planetphotoshop.com

Photoshop Today
www.designertoday.com

ePHOTOzine
www.ephotozine.com

Digital imaging and photography sites
Creativepro
www.creativepro.com

Digital Photography
www.digital-photography.org

Digital Photography Review
www.dpreview.com

Short Courses
www.shortcourses.com

Software
Alien Skin
www.alienskin.com

ddisoftware
www.ddisoftware.com

DxO
www.dxo.com

FDRTools
www.fdrtools.com

Photoshop, Photoshop Elements
www.adobe.com

PaintShop Photo Pro
www.corel.com

Photomatix Pro
www.hdrsoft.com

Toast Titanium
www.roxio.com

Useful Addresses

Adobe www.adobe.com

Apple Computer www.apple.com

BumbleJax www.bumblejax.com

Canon www.canon.com

Capture One Pro
www.phaseone.com/en/Software/

Capture-One-Pro-6 Corel
www.corel.com

Epson www.epson.com

Expression Media
www.phaseone.com/expressionmedia2

Extensis www.extensis.com

Fujifilm www.fujifilm.com

Hasselblad www.hasselblad.se

Hewlett-Packard www.hp.com

Iomega www.iomega.com

Kodak www.kodak.com

LaCie www.lacie.com

Lightroom www.adobe.com

Microsoft www.microsoft.com

Nikon www.nikon.com

Olympus www.olympusamerica.com

Pantone www.pantone.com

Philips www.philips.com

Photo Mechanic www.camerabits.com

PhotoZoom www.benvista.com

Polaroid www.polaroid.com

Ricoh www.ricoh-europe.com

Samsung www.samsung.com

Sanyo www.sanyo.co.jp

Sony www.sony.com

Symantec www.symantec.com

Wacom www.wacom.com